Rome
Sketchbook

To Valerie,
eternally.
FM

Translation from French: Barry Winkleman
Managing Editor: MCM
Illustrations © Fabrice Moireau
Text © Dominique Fernandez

First published in French in 2011 by Les Éditions du Pacifique
5, rue Saint-Romain, 75006 Paris

First published in English in 2011 by Editions Didier Millet
121 Telok Ayer Street, Singapore 068590

Colour separation by Colourscan Co Pte Ltd, Singapore
Printed by Tien Wah Press, Singapore

ISBN: 978-981-4260-43-5
© 2011 Editions Didier Millet Pte Ltd

Rome
Sketchbook

Paintings Fabrice Moireau Text Dominique Fernandez

edm EDITIONS DIDIER MILLET

The Vertiginous Dance of the Centuries

Rome is a palimpsest, a city made of layers of different civilisations piled one on another and intermingled. Put simply, one can count seven distinct civilisations, just as there are seven hills. Starting with ancient Rome, itself subdivided into Republican Rome (the Capitol, the Mamertine Prison, the Forum, the Giulia Basilica, the Temple of Castor and Pollux, the House of the Vestals etc.) and Imperial Rome (the Palatine, the Pantheon, Hadrian's Tomb), then on to Christian Rome (early and Romanesque churches), then Renaissance Rome (St Peter's, the paintings in the Vatican, the Villa Medici) and then to the Rome of the Baroque (the Piazza Navona, Bernini, Borromini) and on to Fascist Rome (EUR) and finally on to modern Rome (Fellini, Pasolini). These seven Romes can only be seen as an ensemble after several visits, certainly not the first time, and even then much depends on one's age, experience and tastes. When I say "then" and "on to" it's only for chronological convenience as there's no real time sequencing in Rome. Each century is the contemporary of all the other centuries, before and after, because, uniquely, the eras refuse to stay separate, classified and compartmentalised.

Found in the Catacombs of San Sebastiano is the famous graffiti of the fish and the IKTHUS acrostic (the Greek word for fish and the Greek initials for "Jesus Christ Son of God"), the secret sign of the first Christians – but also in the basilica of the same name, built in the same catacombs, is an insolently baroque statue, Antonio Giorgetti's *St Sebastian*, a naked, curly-haired young man, leaning back, whose swooning pose evokes ideas that are quite different from those of the severe linear symbol of Christ's early disciples. Fellini tells in his film *Roma* (the best introduction to the city's magic) how, when the authorities tried to excavate the tunnels of the underground railway, frescos hidden since ancient times suddenly appeared from the depths.

One could give endless examples of this interconnectedness of the centuries, be it unintentional or actively sought, so much more convincing when it is unintentional than when it is willed. Thus, Mussolini, as is known, never let up in his efforts to restore its ancient "grandeur" to the city, constructing buildings of questionable majesty and committing the crime of driving the pompously named avenue, Via dell'Impero, from the Piazza Venezia to the Colosseum between Trajan's Forum and the Roman Forum, separating them, and thus disfiguring, thanks to its sheer monumentality, one of Rome's finest and most evocative townscapes. Not everything is deplorable in Mussolini's taste, however, and although one will be frowned on for saying so, the stadium built for the 1932 Olympics is decorated with statues of naked athletes whose beauty would in no way disgrace a museum of antiquities.

The first time I went to Rome, as a classics student, I only had eyes for ancient Rome, known to the world as *Urbs*. I strode through the forums, identified temples, picked out basilicas, climbed the Palatine hill, clambered up the terraces of the Colosseum, walked the Appian Way, whose cobblestones had survived intact since the time of Cicero and I sat before the tomb of Cecilia Metella in a drunken orgy of classical culture that blinded me to the city's other epochs.

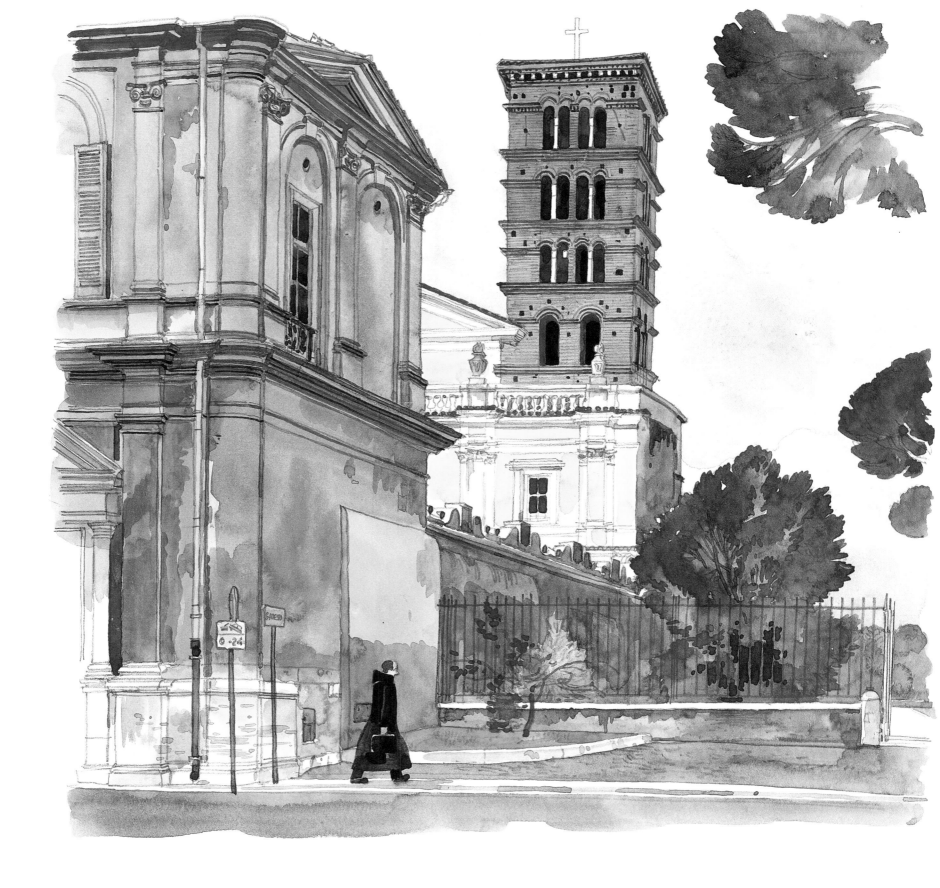

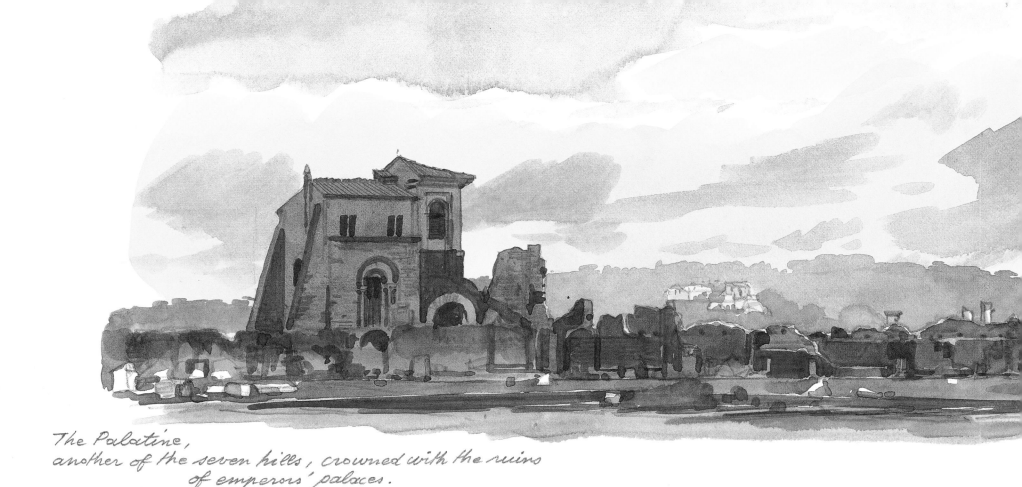

The Palatine,
another of the seven hills, crowned with the ruins
of emperors' palaces.

I do not think I was alone in this, since even in 1983, a renowned professor at the Sorbonne, the late lamented Pierre Grimal, published a guidebook called *Nous partons pour Rome* (*We're Leaving for Rome*) in which he informed his readers that the last date of note in the history of this city was the building of the wall of the Emperor Aurelian … in 270 AD! As if nothing of importance had happened since, as if the chief characteristic of Rome were not, on the contrary, constantly to bounce back, to renew itself, each new culture in competition with its predecessor and without hesitation borrowing its elements, pillaging and confiscating and distorting them, re-using them unscrupulously for its own benefit.

I remember my indignation when I found out that the popes had stolen stone from the Colosseum to build St Peter's and that they hadn't hesitated either in robbing this same Colosseum – good for anything – of material for their own palaces. I well remember my fury in discovering that Bernini had purloined the bronze from the portico of the Pantheon for his famous canopy in St Peter's. I was also most displeased to find, in the middle of the Forum, the imperial library replaced by a catholic sanctuary, Santa Maria Antiqua. Or as if springing from the ruins of the most venerable meeting-place in antiquity, a baroque monument that had no place there at all, the Church of Santi Luca e Martina.

I was misunderstanding the unique genius of this city – a disdain for conservation, an unending thirst for the new made

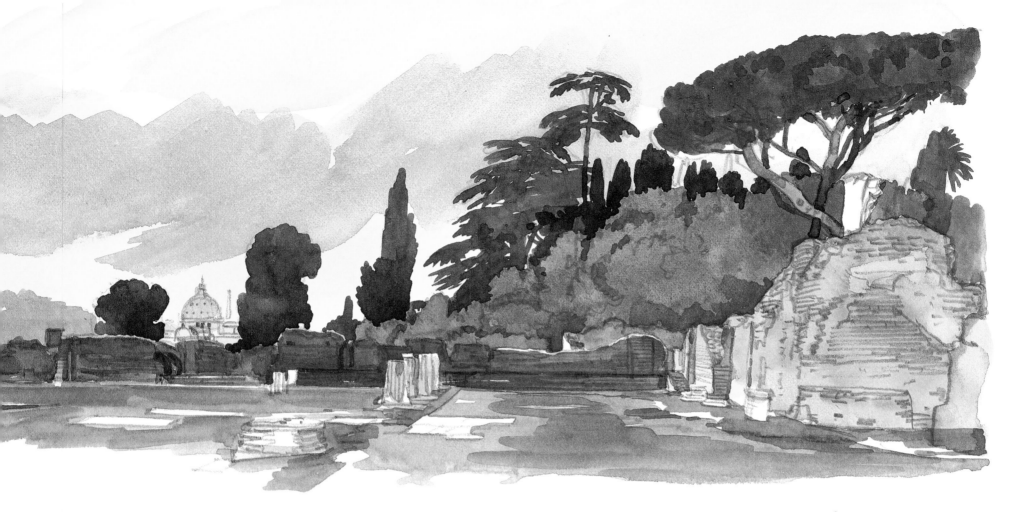

from the old. What extraordinary vitality! No conventional respect for monuments and an insolent creativity that starts up again every century. No unity but a staggering confusion, a lovable mish-mash. One false note in this brilliantly heterogenous jumble is the hideous white mass of the Victor Emmanuel monument, stuck like a wart on the face of the Piazza Venezia, on the holy décor of Santa Maria in Aracoeli and the palaces of the Capitoline.

Today on the contrary, I admire this disharmony – itself the creator of a superior harmony. I now like discovering columns in a romanesque church that must have been taken from some pagan temple or finding on the Via Ostiense, in the direction of San Paolo fuori le Mura, a museum of ancient statues set up in the disused Montemartini power station. Here, in the midst of the pipework, machines and turbines that remain, one can walk over gangways and iron bridges and discover, while weaving one's way through immense metallic structures, such fine statues, in particular one of the most beautiful heads of Antinoüs to be seen.

Where should one start a visit to Rome? Its monuments are so intertwined, so narrowly juxtaposed, in so intimate a cohabitation that to sort out the tangle, to trace a logical itinerary is virtually impossible. There are no distinct quarters as there are in Paris or London, everything is contiguous, mixed, everything overlaps and interweaves, every historic period is everywhere and each place is of every period. But it

The Ponte Fabricio,
which leads to Tiber Island,
dates from the 1st century BC.

happens occasionally that this superposition of the centuries in one place allows one to grasp in one go the multiplicity of the ages. Thus the Basilica di San Clemente, near the Colosseum, presents on three floors, of which two are below ground, three separate epochs. On the lowest level the remains of Roman houses and a Mithraic temple are from ancient times; next floor up is an early Christian church of the 5th century; finally, at street level, the basilica, which is from the 12th century. But even this is the focus of many cultures, since, if the body of the church is medieval, the sixteen columns that divide the three naves are antique, the frescos that decorate the chapels are 15th century, in the great quattrocento style, and the ceiling is covered in baroque frescos of the 18th century.

How can one escape this giddy dance of the centuries? One idea might be to head for the River Tiber, which flows through the city and which ought to form a poetic and spiritual axis, as the Seine is an essential element in the Parisian townscape or the Neva is of the majesty of St Petersburg. But the Tiber is as if absent from Rome, it takes no part in the décor of Rome, it looks as though it were just passing through by chance for nobody strolls along its banks, which, by the way, are not at all refurbished, though they have a certain sad, neglected charm. The Emperor Hadrian identified the Tiber with the river Styx, the river of the dead, and built his mausoleum, which we know as the Castel Sant'Angelo, on the bank that he thought of as the empire of the dead. Is this why the quays are deserted? Greek and Latin myths retain much power still in Rome, and it is not impossible that the great emperor's shade still casts a taboo over the banks of the Tiber.

From the Ponte Sant'Angelo one's eye is glued to the heavy cylindrical mass of the formidable tomb. In the popular imagination some cities are light and others are perceived as heavy. Venice is light, with its gondolas and their tapering prows and its stone rosettes; Florence, too, is light with its finely carved towers; Bruges, also, with its buildings of lace and its ethereal belfry; Cambridge is light with the flamboyant Gothic of its chapels and its willow-shaded river. Munich, whose buildings seem fed on beer, on the other hand, is heavy; heavy, too, is Paris, anchored to the banks of the Seine; but heavier than all of them is Rome, the city we call eternal as if, in its monuments, it sums up the history of humanity, as if the weight of so many centuries rests on its ancient stones.

Pagan Rome has bequeathed us some of the most colossal and massive buildings ever created by man: the Colosseum, the baths of Caracalla, Hadrian's tomb. The Basilica of Constantine was 100 metres long and 76 wide and the pillars of the central nave were 35 metres high. The blocks of masonry that have fallen to the ground from its ruins give an idea of its gigantic proportions. Christian Rome added to its cupolas, the biggest of which, St Peter's, looks like a lid placed on the whole agglomeration. Light cities have steeples, heavy cities have cupolas. Steeples climb and pierce the sky; domes cover, crush and stifle. To the ascending power of a steeple is opposed the oppressive weight of a cupola or dome. The circular shape of a dome leaves no place for freedom. The sphere symbolises perfection and a city with a headdress of hemispheres is as if locked forever in a disciplinary corset.

There are few steeples in Rome and few, in its long history, political freedoms. Emperor, Pope or Duce – there's always someone to grab power, punch heads and remind Romans that

A statue from the museum
of antiquities recently established
in an old power station.

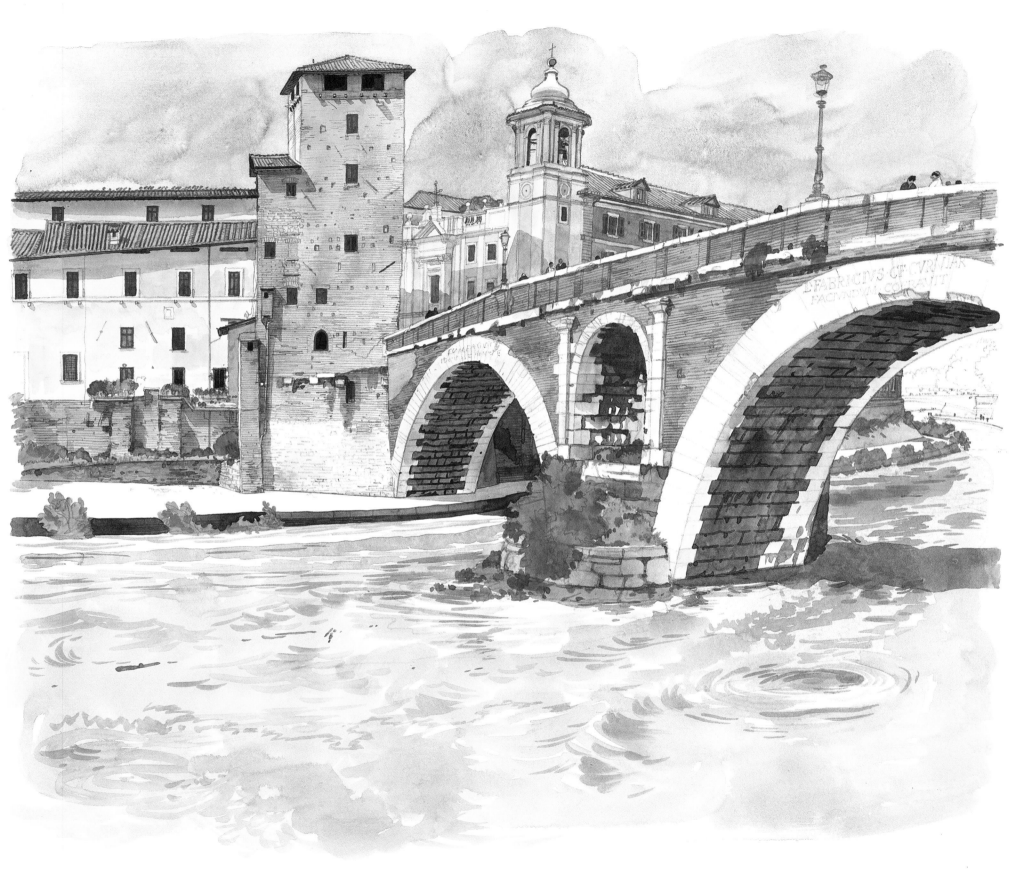

The Church of Santa Maria Maddalena, remarkable for its façade and baroque lantern, is 15th century, rebuilt in the 17th. Not far from the Pantheon.

they must obey. Of all the towns of Italy that won municipal independence so early and expressed it in the form of towers and steeples (remember the rivalry of Florence and Siena and the struggle to build the highest belfry), Rome is the only one that immediately and for all time let its visage be crushed by the weight of domes.

For all that I have loved visiting and revisiting this city I cannot but deplore the negative results of this continual submission to authority. The Church substituted itself for the Roman Empire as ruler of the world, to continue the universalist mission started by Augustus, the Holy See exercises a powerful censorship over the territory placed under its direct authority, that is to say, Rome. For centuries the Vatican has sterilised the cultural and literary life of the Italian capital and continues to atrophy it. No great publisher, no great newspaper, no important theatre or art gallery of real note – not even Rome's opera house has ever achieved any real fame. Italians go to Rome because that's where the power and the money are. Thus, in the past, Virgil hurried here from Mantua, Horace from the depths of Apulia, Michelangelo from Florence, Raphael from Urbino, Caravaggio from Lombardy, Canova from Venice and in our own day Ungaretti arrived from Alexandria in Egypt, Pasolini from Friuli, Carlo Levi from Turin, Giorgio Bassani from Ferrara, Fellini from Rimini, Visconti from Milan. Rome, herself, has scarcely produced a single great man. "Rome, the capital of boredom", said Chateaubriand, whom one cannot accuse of anti-clericalism, but who could not avoid seeing how the dominance of priests had stifled the life of the mind.

City of heaviness, city of stone, in all senses of the word. Nowhere else is one so aware of the physical presence of

A detail of the façade of the
Church of Santa Maria dell'Orto,
based on a design by
Giulio Romano.

stone as in Rome, perhaps because of the presence of so many ruins which show the stuff in its raw state. In Paris, in Madrid, in St Petersburg, one looks at houses; in Rome, one looks at the trunks of columns, at blocks of marble, plinths of limestone. Every vestige, in ageing, has taken on its own beauty, quite independent of its function in an architectural ensemble. The stones live for themselves, with their grain, colour and smell. The column of the temple of Vesta, whose flutings have been erased by time, has returned to its original state, to the immemorial time when it was just a fragment of mountain before the efforts of man to sculpt it. That is what moves me so, this return to formlessness. Magnificent too is the survival of walls when the rest of the edifice has crumbled. Walls that exist in their absolute beauty, deprived of any purpose, such as the wall of the Villa Adriana, which stands among olive trees and sings, at the gates of the city, of the fraternal strife between mineral and vegetable. Collapsed sections of the Basilica of Maxentius, broken down arches in the baths of Caracalla, paving stones from the Forum or the Appian Way – the stones of the *urbs* speak the rough language of primordial geological forces.

Corrected, amended, softened by the presence of fountains without number, water flows in torrents in Rome but the living water is not that which sweeps lazily down the river, the water that interests Romans, the water that they have enshrined in wonderful finery, is that which gushes from the mouths of fountains. One possible itinerary would be a tour of the fountains, the oldest, it is thought, being that on the Capitol where the water exits through the snout of a she-wolf. The most famous is of course the Fontana dei Quattro Fiume in the Piazza Navona. The first time I was in Rome I did not even notice it! At that time the Baroque was still considered overblown, in "bad taste", scorned and vilified. Bernini brought all the elements of baroque together in this fountain: gigantism and the unsteady pose of the four statues representing the four great rivers of the world, the Danube, the Nile, the Ganges and the River Plate; the make-believe of natural uncarved rock; unusual flora and fauna in the basin: a palm-tree, a crocodile and an armadillo; streaming water, that turns inanimate stone into living matter by its continual movement and the ever-changing glitter of light. Instability, metamorphosis, exoticism, mobility, theatrical illusion – it's all there.

The Trevi fountain is the most spectacular: as high and wide as a palace, a real shop window of the Baroque featuring Ocean's chariot drawn by two horses ridden by tritons. But to this grandiose stage design, I prefer a thousand times the more secret and poetic fountains: the fountain of the Scrofa, or sow, made from a relief inlaid with a sow in a wall in a street near the church of Sant'Agostino; the triton fountain in the Piazza Barberini and the fountain of the bees at the bottom of the Via Vittorio Veneto, also by Bernini. The exquisite fountain of tortoises in the Piazza Mattei, decorated with four young men leaning on the dolphins that are watering the tortoises; the fountain of sea horses in the gardens of the Villa Borghese; the Barcaccia fountain at the foot of the Spanish Steps, named because it shows a barque, about to sink,

allegory of the uncertainty of human existence. Note that bees, that one can find on monuments all over Rome and not just on fountains, were the emblem of the Barberinis, the family of Pope Urban VIII, Bernini's protector and the city's brilliant town planner: an example of the talent of sculptors in symbolising political power in the most graceful of images.

Since we are now at the foot of the Trinita dei Monti, let us climb this staircase (the Spanish steps), the most famous corner of Rome. Thousands of tourists sprawl over its steps oblivious to the idea that lay behind its construction. At the bottom, then, the sinking barque; then the 137 steps to climb; finally, at the top, the obelisk, put up there in 1789 by Pius VI in front of the church of Trinita dei Monti. The meaning is clear – the whole ensemble represents the archetypal journey for a Christian: from the miseries of his life on earth to salvation through the Church after a hard climb guided by the hand of God (the obelisk). At the very moment the people of Paris were storming the Bastille at the outbreak of the French Revolution, the Pope was inscribing his theological message on the very topography of Rome.

A deviation on our itinerary and here we are, on the left, at the top of the great stairway, in front of the Villa Medici, a temple to pagan culture. Not only do the centuries clash in Rome, but the sacred and profane collide as well. It was a cardinal who made this splendid building – but a renaissance-style cardinal. Son of the Duke of Tuscany, raised to the purple aged but fourteen, he was not even a priest and the only interest he took in his position was to gather

its considerable stipends. Ferdinando de Medici was one of those lavish benefactors of the arts to whom Rome owes much of its beautification in the 16th and 17th centuries. He extended and rebuilt an earlier structure, built the majestic staircase at the entrance, redesigned the interior façade, redeveloped the loggia and gardens and filled the palace with masterpieces of painting and sculpture, which today have been mostly dispersed to museums throughout Italy: the Medici Venus; Benvenuto Cellini's *Ganymede*; the Greek Niobids group; Giambologna's *Mercury*; Raphael's *Madonna della Seggiola*; a Giorgione, a Titian … the two lions under the loggia that flank the Mercury were carved from giant capitals taken from the Palatine. The lion, emblematic of Florence, was a reference both to the cardinal's place of birth and to his birth sign, as he first saw the light of day at the end of July. His villa gardens, where the beds are neatly enclosed in boxwood hedging and run alongside a wood left in its wild state, offer the visitor one of the finest walks he can take in Rome. Whether he has the classical taste for regularity or a weakness for pre-romantic disorderliness, he will be equally satisfied. Forgetting one's surprise at finding in the last bed a group of Greek statues set there by Balthus, a group of Niobids, that completely wreck any rational ideas one might have about the diversity of styles – they offer the very image of baroque swoonings and agonies.

Two other Roman palaces show off the splendour displayed by the princes of the Church. Cardinal Alessandro Farnese, immor-

A wall in typical
Roman colours on the
Via Barberini.

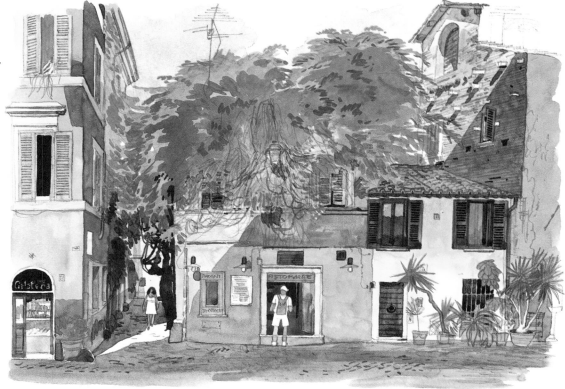

talised by Stendhal as Fabrice in *The Charterhouse of Parma*, built the Farnese Palace, starting in 1514, today the French embassy and the most magnificent palace in Rome. It was started by Sangallo and finished by Michelangelo. It contains the mythological ceiling painted by the Carracci brothers, but the collection of antiques put together by the cardinal has been dispersed. The finest pieces are in Naples, the Farnese Hercules and the Farnese Bull still bear the name of the man who retrieved these treasures from the ruins of the baths of Caracalla.

There remains the Casino Borghese, still rich in masterpieces gathered there by Cardinal Scipione Borghese – he also was made cardinal when very young, by Pope Paul V, his uncle – who collected some wonderful Bernini statues and some pictures of the greatest beauty, of which six are by Caravaggio, whom he greatly admired. Wandering through the rooms of what is now the Borghese Gallery is to immerse oneself in this Rome of the Baroque, which is for me, of all possible Romes, the most original, the most provocative and utterly modern. To explore it, two incomparable guides are available, namely Caravaggio and Bernini. It suffices to follow them to the places where they left their works to discover a townscape that is the precise opposite of French classical taste.

Caravaggio, at the end of the 16th and the start of the 17th centuries, inaugurated the Baroque era, which immediately took on a violent and wild character in his hands. One can only dream of what Rome would have become if the Church, which at first encouraged him, had not finished by censuring his pictures as decidedly too bold and too disturbing. "This great painter was a villain," Stendhal said of Caravaggio two hundred years later, and indeed the authorities took it upon themselves to muzzle him by censuring his pictures. If in the church of San Luigi dei Francesi, near the Piazza Navona or in Santa Maria del Popolo, in the Piazza del Popolo, the canvasses ordered by the clergy are still in position, one looks in vain in Santa Maria della Scala, in Trastevere, for *The Death of the Virgin*, a painting that was refused (it's now in the Louvre) because the artist took as his model for the Madonna, the body of a prostitute fished out of the Tiber. Picking up the traces of his works in the various churches and museums of Rome is a fascinating experience: one goes into Sant'Agostino to see the *Madonna of the Pilgrims*, to the Palazzo Barberini, the *Narcissus* and the terrifying *Judith Beheading Holofernes*, whose cruelty is so implacable that one thinks, looking at the blood flowing from the general's cut-open throat, of the tales of revenge and murder in Stendhal's *Chroniques Italiennes*. In the Palazzo Corsini, in Trastevere, the *St John the Baptist* has the air of one of Pasolini's ragamuffins picked up from the slums.

In the Vatican picture gallery, *The Descent from the Cross*, as powerful as a Michelangelo; in the Palazzo Doria Pamphili, the *Rest on the Flight into Egypt* and the *Magdalene Penitent*; in the Capitoline Museum, another St John the Baptist of a shameless immodesty; finally in the Borghese Gallery, no less than six paintings, among which are *The Boy with the Basket of Fruit* with the languid pose and the stunning *David and Goliath* where the painter used himself as the model for the decapitated head of Goliath, foreseeing perhaps his own death a short time later, on a deserted beach to the north of Rome, where he was no doubt murdered. His end is wrapped in mystery but it resembles so strongly the murder of Pasolini, also killed on a beach near Rome, a crime whose circumstances are well known, that one cannot help make a connection between the two tragedies.

Rome is not only a pile of ruins and stones, it's a living place haunted by extraordinary personalities. I love the city for its streets, for its squares and its fountains but also, and perhaps primarily, for the great men who braved the authorities and the censorship they enforced: Michelangelo, whose *Last Judgement* in the Sistine Chapel was threatened with destruction by a Pope for its display of virile male nudes, considered indecent; Caravaggio; Giordano Bruno, the philosopher, precursor of Spinoza and of modern pantheism, arrested and burned alive by the Inquisition in 1600 in the Campo dei Fiori, where today his statue faces the buzz of a popular market; Pasolini; in short all those who were under the surveillance of the authorities and who were finally rendered incapable of harming the established order, religious orthodoxy, good manners and political correctness.

The case of Bernini is quite different. He too is omnipresent

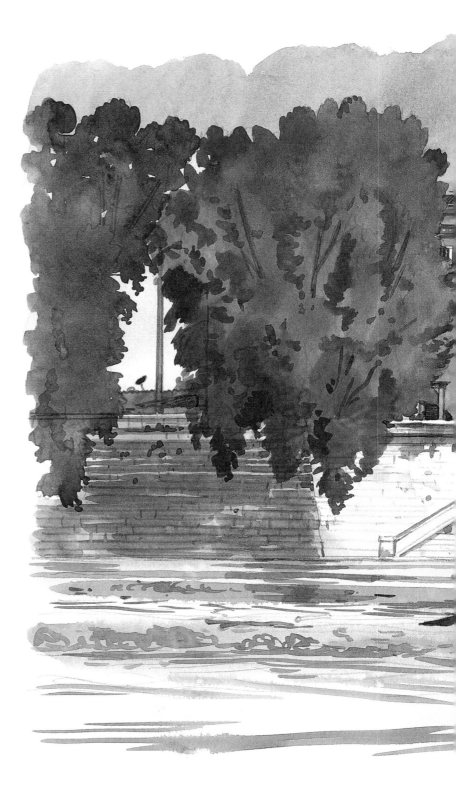

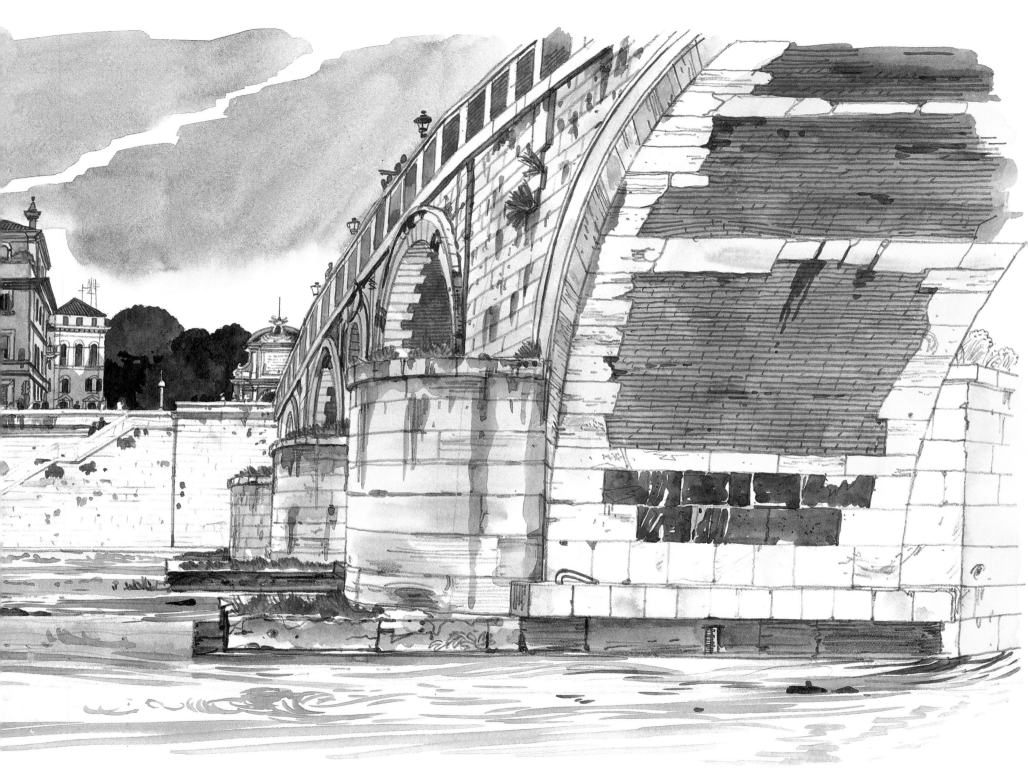

The Ponte Sisto was built on the orders of Pope Sixtus IV in the 15th century. It links the Campo dei Fiori district to Trastevere.

in Rome, but he was protected, financed and feted by popes. In the 17th century he was instrumental in changing the look of the city. He led a long and glorious life, the opposite of the violent and half-secret life of Caravaggio. And since his works are those of an architect, a decorator and a sculptor, they are more immediately visible than those of a painter and are a real part of Rome's townscape.

Let us start with St Peter's and the famous colonnade raised in front of the basilica and running around the square, an immense Doric portico divided into two semicircles of four rows of columns, which form three galleries. He had to evoke the universality of the Church and its desire to open its arms to the whole world. Inside the basilica is the no less renowned canopy, made with bronze taken from the Pantheon, St Peter's pulpit built at the end of the apse in a glory of clouds, sunbeams and angels. And finally the spectacular tombs of Urban VIII and Alexander VII give an idea of the pomp Bernini loved to display

and the means at his disposal.

Such gigantism was, happily, but one route, albeit extreme, explored by Bernini's genius. He knew, too, how to distance himself from ostentation and pomp. There is nothing more graceful than the angels sculpted for the Ponte Sant'Angelo or more sensual than the two saints carved in ecstasy, Santa Theresa and the happy Ludovica Albertoni, in Santa Maria della Vittoria and San Francesco a Ripa respectively. Seeing these mouths twisted by celestial visions, this ferment of rumpled cloth, this overflow of emotion, more pagan than Christian, this rampant eroticism, it must be said that Bernini did well to be the official papal artist. He remained enough of an Italian to keep his freedom and the impudence of a style utterly at loggerheads with biblical precept.

The various fountains, already mentioned, of the rivers, the Triton and the bees have left their mark on Rome forever through their fantasy and their humour – take for example the elephant placed by Bernini as a pedestal to the obelisk in the Piazza della Minerva, a crazy but enchanting invention. In the façade of the Palazzo Montecitorio, which serves today as Italy's Parliament, great blocks of unhewn stone have been inserted, which is yet another typically baroque innovation by Bernini – this manner of integrating nature with architecture, as if the latter were an extension of the former, a notion that would have horrified Michelangelo.

The Bernini tour ends in the Borghese Gallery where his four masterpieces of sculpture are exhibited. It is not for us to analyse them here but simply to underline how they sum up what makes for the originality of Rome. In *The Rape of Proserpine*, Pluto's hand digging into the victim's thigh shows the same greedy

The spectacular costumes of the Swiss Guard were reportedly designed by Michelangelo.

sensuality to be seen in the faces of the youths that wander the Pincio gardens or stroll the long avenue of the Corso. As for his *David*, it allows us to define clearly in which way the spirit of Rome differs from the spirit of Florence. In Florence, of course, Michelangelo raised his monumental, haughty and timeless David, standing firm, ready to defy the powers of evil, an allegory of strength and courage. Bernini's *David*, shown twisting his body in vigorous movement, an unsettled hero, tense and anxious, is nothing like that. To Florence, pure and confident of its rights, is opposed a doubtful self-questioning Rome. This is what modifies our impression of a city subjected to the authority of the Papacy and dominated by its power. It is true that the popes put vine leaves on ancient statues, bronze loincloths on the too-daring statues of Renaissance artists and there was even one who put underpants all over Michelangelo's *Last Judgement* – but it's precisely this authoritarian mania to control that encouraged artists to rebel, to assess just how far their creative freedom would stretch. Pluto's hand on Proserpine's flesh, the bare thigh and swaying pose of the angel with a scroll on the Ponte Sant'Angelo, the emotional turmoil of Ludovica Albertoni, the fevered amorousness of Santa Theresa: these are all attacks against orthodoxy, all good reasons to love Rome (*Roma*, anagram of *Amor*.)

The best advice is to read nothing about this city before gathering one's own impressions. From Montaigne to Goethe, Chateaubriand to Stendhal, Michelet to Zola, Taine to Henry James – so many magnificent and interesting words, so many obstacles between Rome and the personal vision that each one of us should have of the city. One must leave it to chance and wander aimlessly, without fear of missing out the conventional sights. Pleasure is found where least expected: in a secret corner between two shady lanes; under an umbrella pine sprung from between two paving stones, by railings behind which lies a hint of mystery, in the darkness of a chapel where a candle-end flickers, before a stele that evokes a far distant past.

What is more poetic, for example, than the Aventine Hill, where few visitors venture, for there is no famous monument to be found there? It is a silent, secluded neighbourhood of villas, monasteries and gardens. One feels very far from that other hectic, clamorous Rome on these roads resembling country lanes, bordered by walls abundantly overhung with olive trees, cypresses and pines. In Santa Sabina, a vast 5th-century basilica, one can savour another well-ordered assortment since the tall Corinthian columns come from a pagan temple.

Another unexpected pleasure to be found in Rome is the non-Catholic cemetery where some Englishmen are buried, including Keats and Shelley, and Goethe's son, some orthodox Greeks and Russians and communists such as Antonio Gramsci. It's a delightful garden, itself a witness to the fabulous patchwork that is Rome. On the left stands the white marble tomb, in the form of a pyramid, that Caius Cestius, a distinguished citizen of Augustus's Empire, had built for himself, at a time when Egypt was the height of fashion; and on the right, an absolutely magical place, the Testaccio, a mound made from piles of broken, ancient amphorae, a rendez-vous today for boys grazing horses and hoodlums that seem to have escaped from a Pasolini film: yet again, a crossroads where different cultures meet, a space where the most distant past merges with the most immediate present.

Translated from the French by Barry Winkleman © 2010.

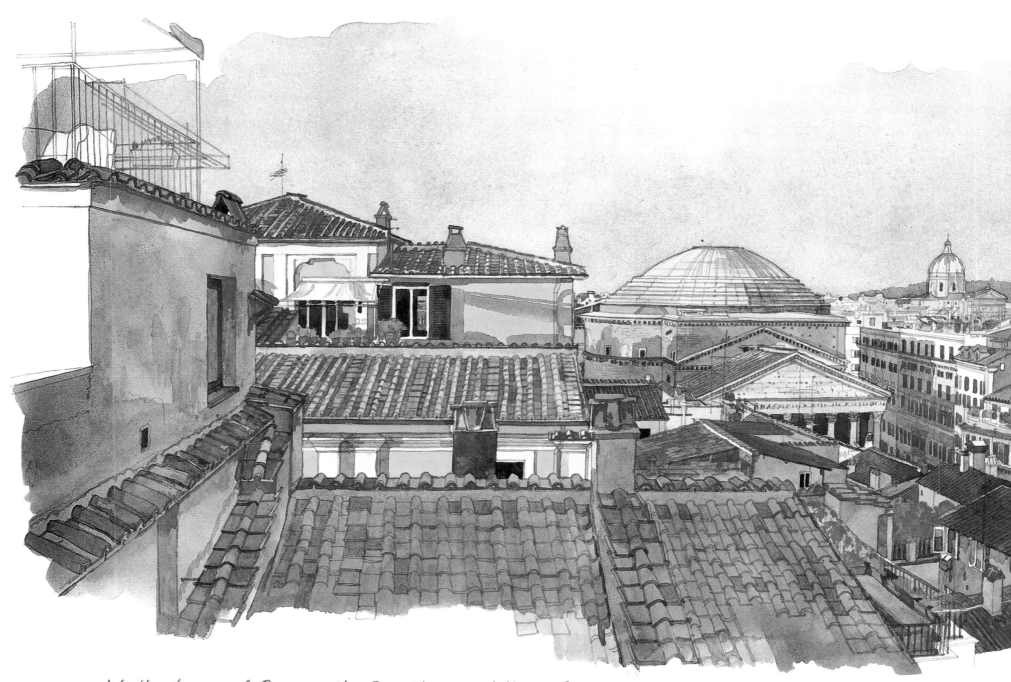

At the heart of Rome, the Pantheon, with its flattened dome and perfect shape, into which light enters through an oculus in the centre of the vault, is one of the finest examples of ancient architecture. The Janiculum hill is in the background.

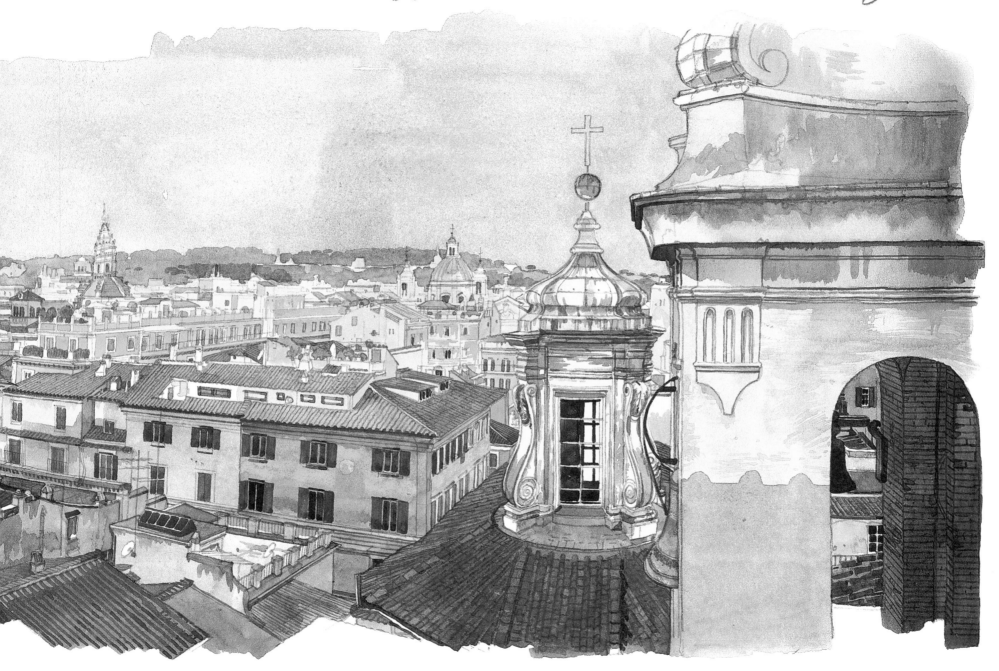

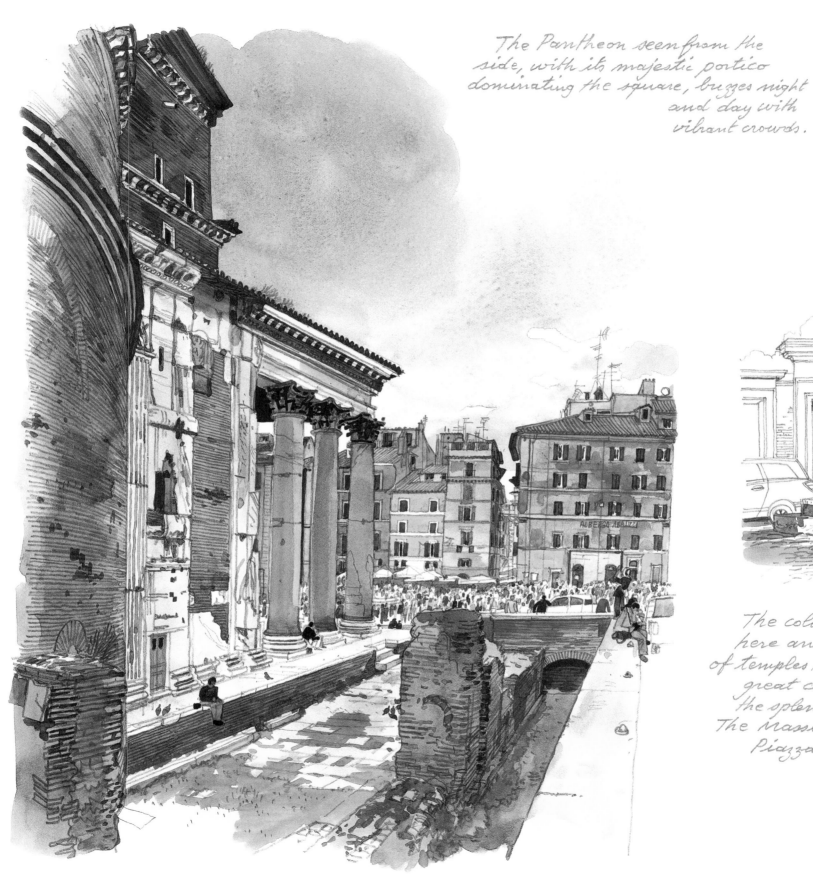

The Pantheon seen from the side, with its majestic portico dominating the square, buzzes night and day with vibrant crowds.

The columns that stand here and there are remains of temples that link the great city of today with the splendour of the past. The Massimi column, Piazza dei Massimi.

The Piazza della Rotonda,
in front of the Pantheon,
is ornamented with a
16th-century fountain.
In the following century, an
obelisk found in the ruins,
with hieroglyphs from the
period of Rameses II was placed
on top of it.

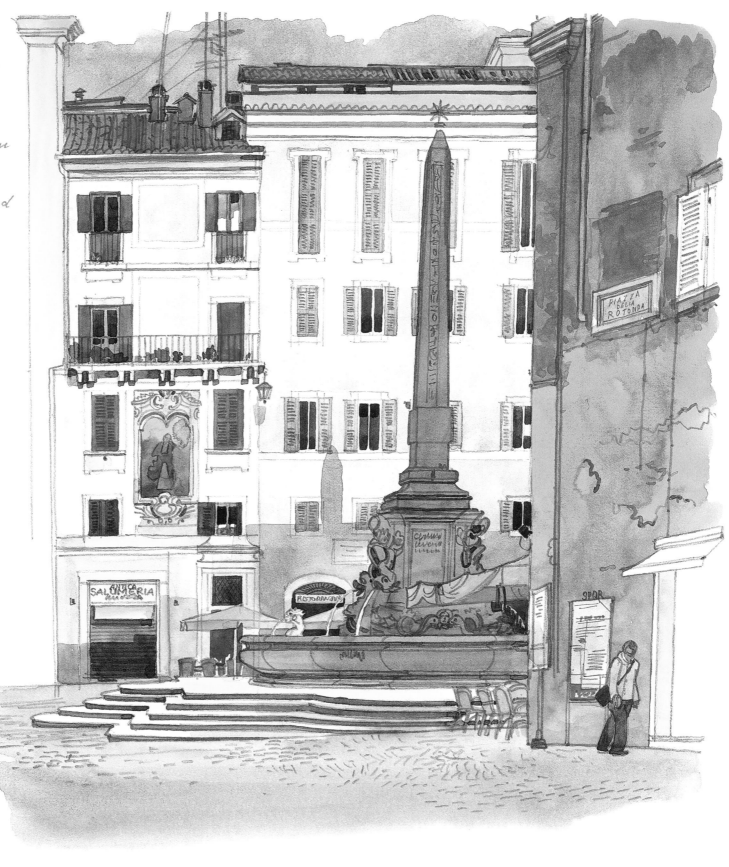

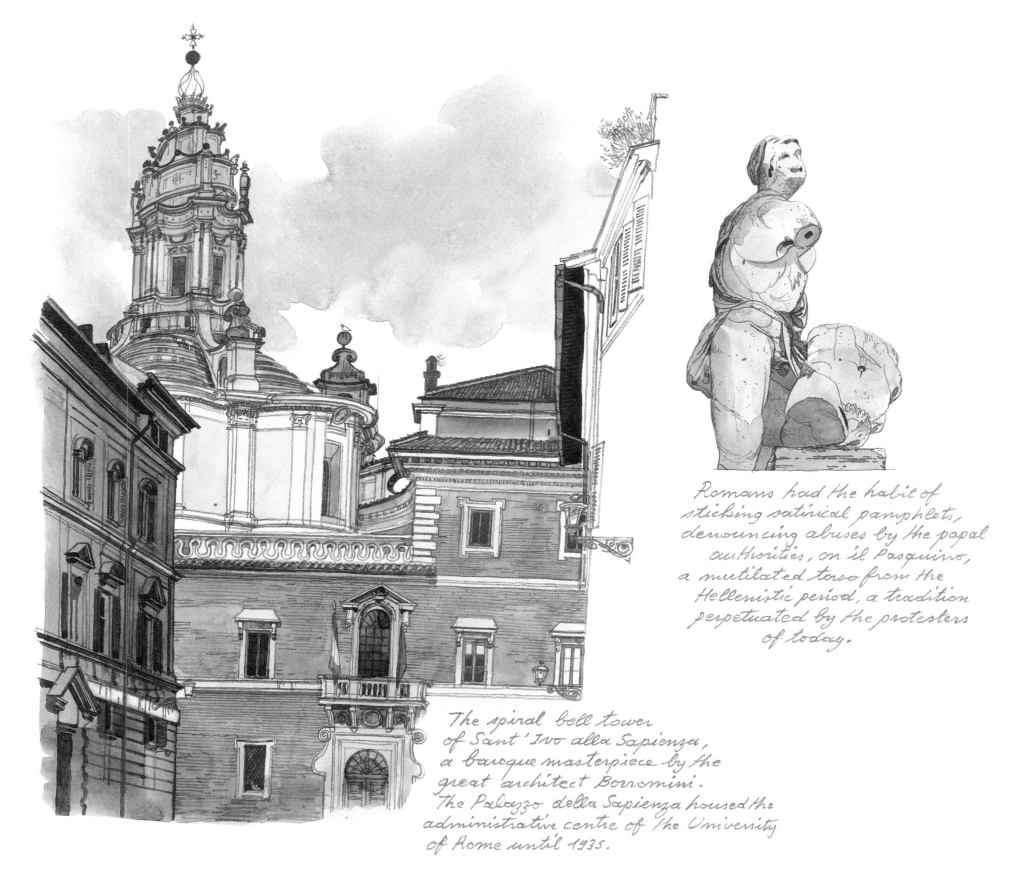

Romans had the habit of
sticking satirical pamphlets,
denouncing abuses by the papal
authorities, on il Pasquino,
a mutilated torso from the
Hellenistic period, a tradition
perpetuated by the protesters
of today.

The spiral bell tower
of Sant' Ivo alla Sapienza,
a baroque masterpiece by the
great architect Borromini.
The Palazzo della Sapienza housed the
administrative centre of the University
of Rome until 1935.

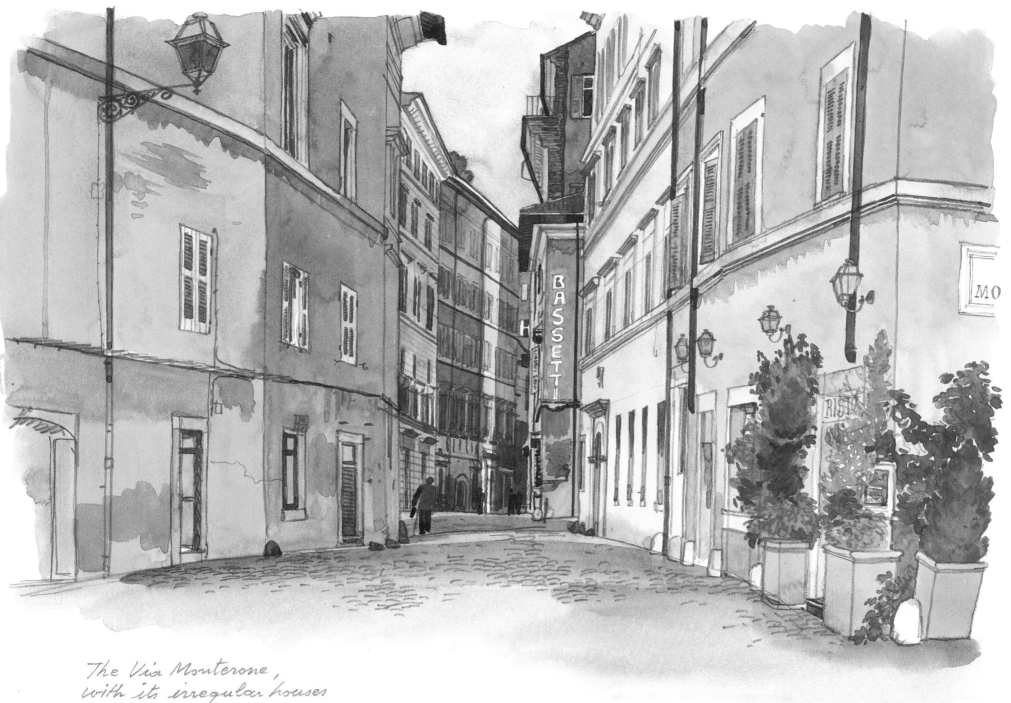

The Via Monterone,
with its irregular houses
and coloured façades,
is one of the finest and most
picturesque streets in the historic
centre. The absence of pavements
adds to its charm.

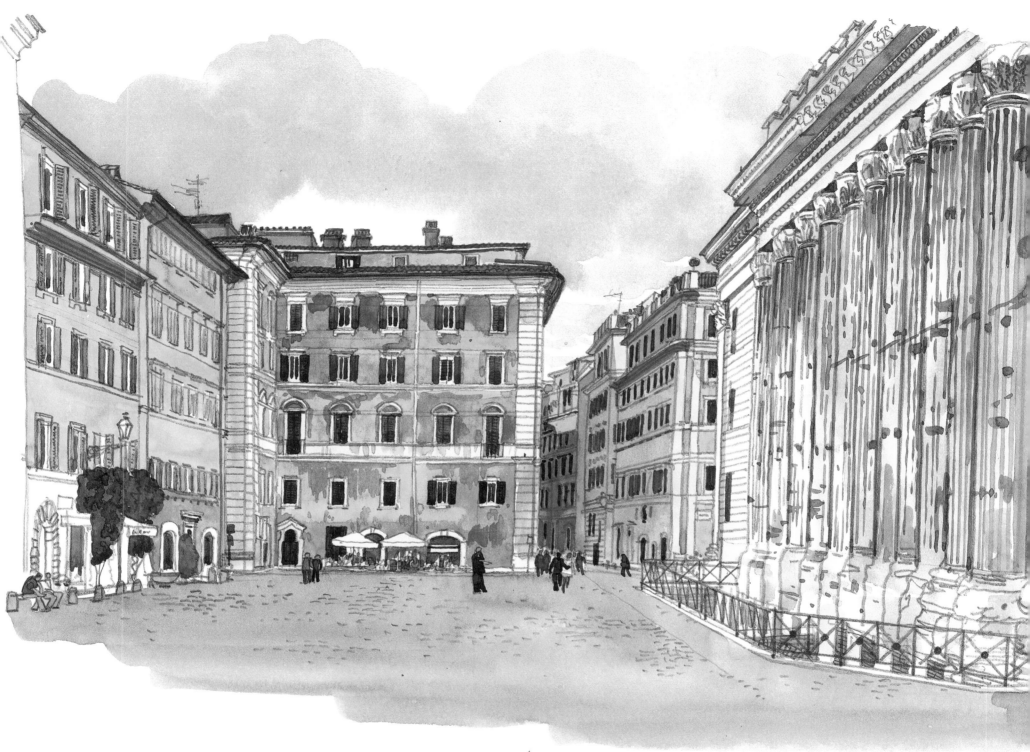

The Piazza di Pietra, where one can see the
remains of a temple dedicated to Hadrian,
is yet another example of the happy coexistence of
the modern town and the ancient city. At the far
end of the square stands La Caffettiera, the city's
most famous Neapolitan café.

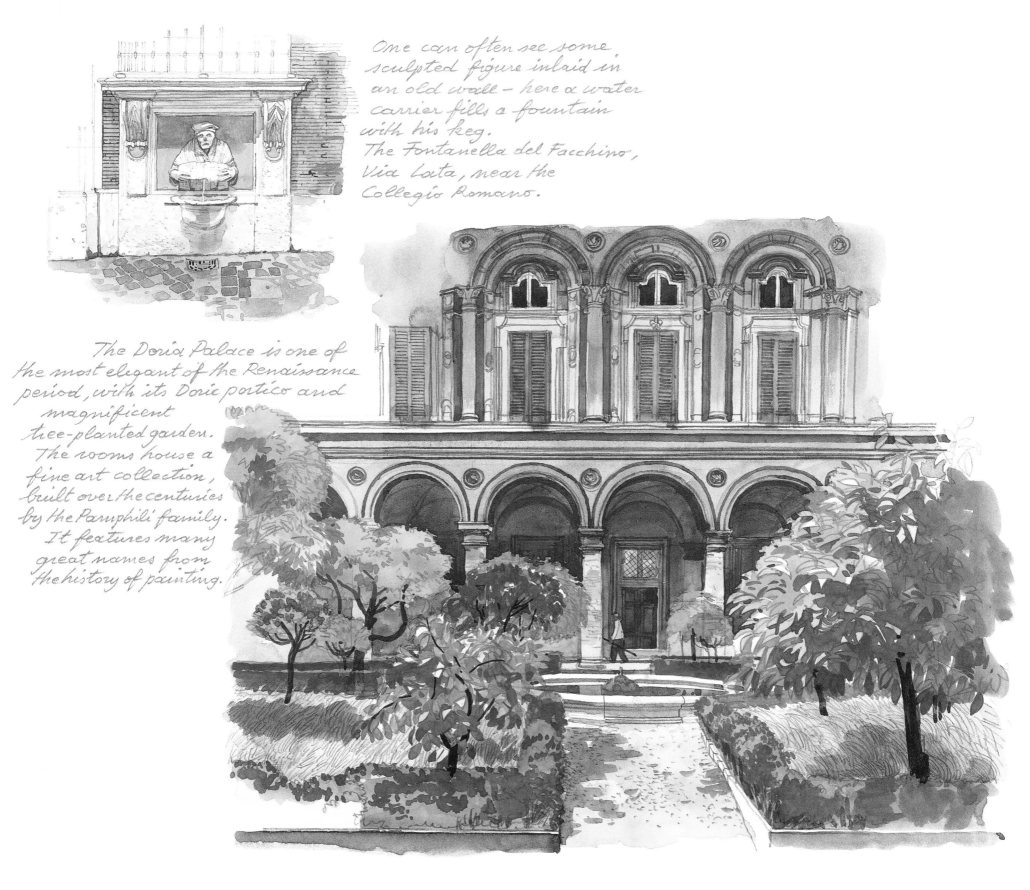

One can often see some
sculpted figure inlaid in
an old wall – here a water
carrier fills a fountain
with his keg.
The Fontanella del Facchino,
Via Lata, near the
Collegio Romano.

The Doria Palace is one of
the most elegant of the Renaissance
period, with its Doric portico and
magnificent
tree-planted garden.
The rooms house a
fine art collection,
built over the centuries
by the Pamphili family.
It features many
great names from
the history of painting.

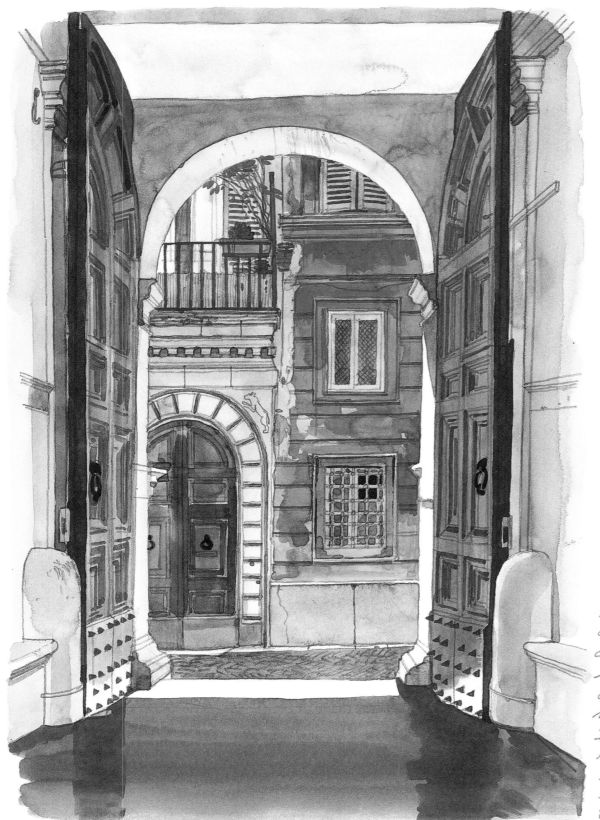

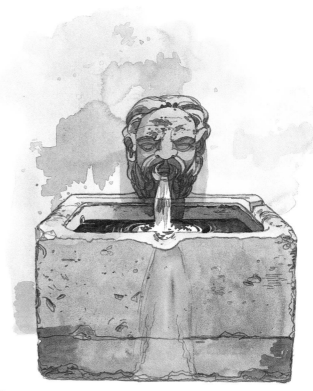

Fountains are scattered throughout
the city, sometimes consisting only
of a simple stone basin
where the water flows from the
mouth of a fantastic masked
figure.

A marvellous characteristic
of Roman palaces is that they can open
on to the street without warning,
through a vast portal that you fall upon
at the last moment, leading to a
magical courtyard.
It was from the Palazzo Baldassini on
the Via delle Coppelle that Garibaldi
made a famous speech about the
embankments by the Tiber. They were
to change greatly the look of the river.

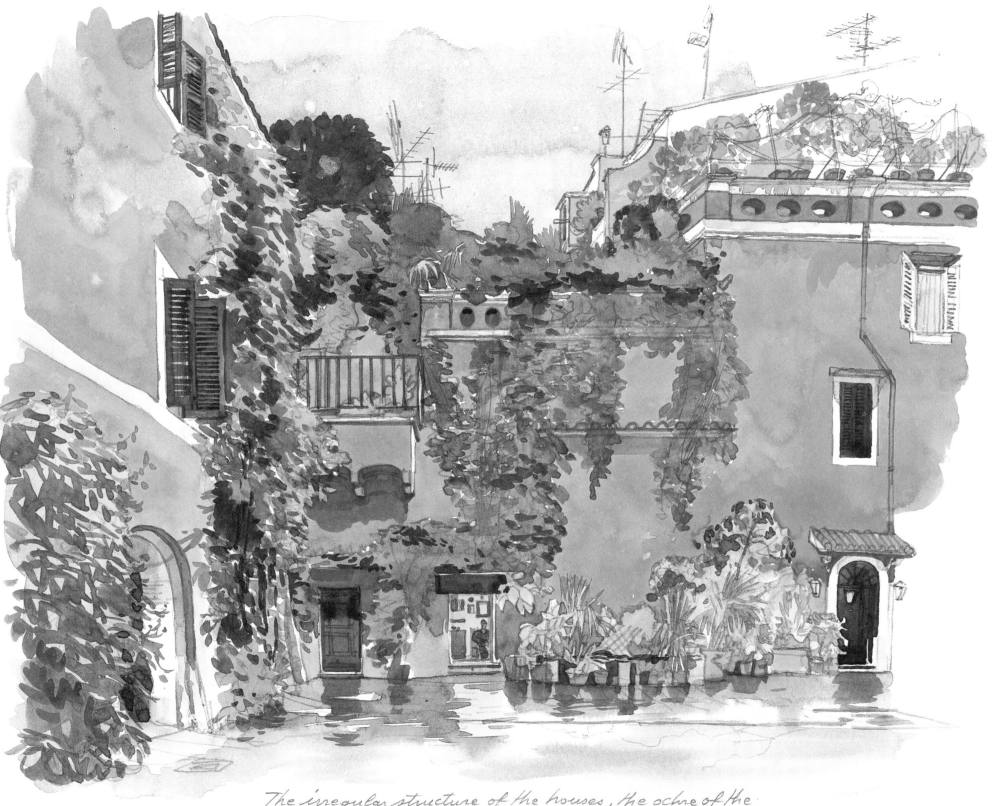

The irregular structure of the houses, the ochre of the walls, foliage sprouting from the stonework — it's this poetic jumble that is Rome's great magic charm. Courtyard on Via della Stelletta, a few steps from the Piazza Navona.

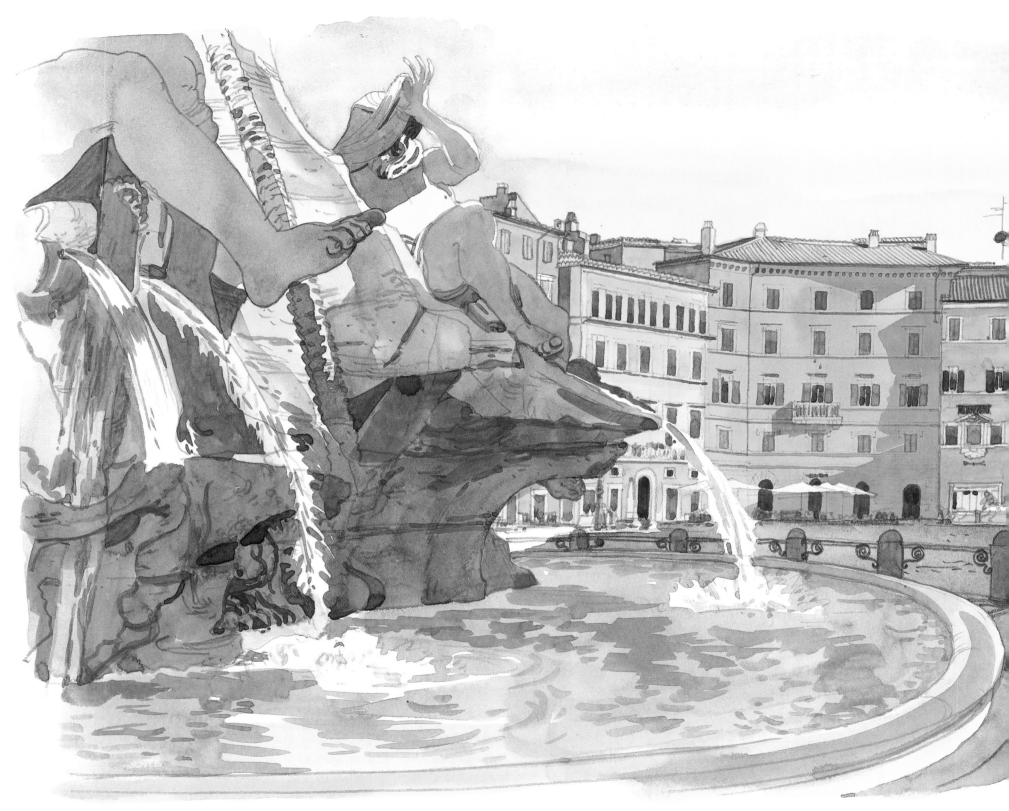

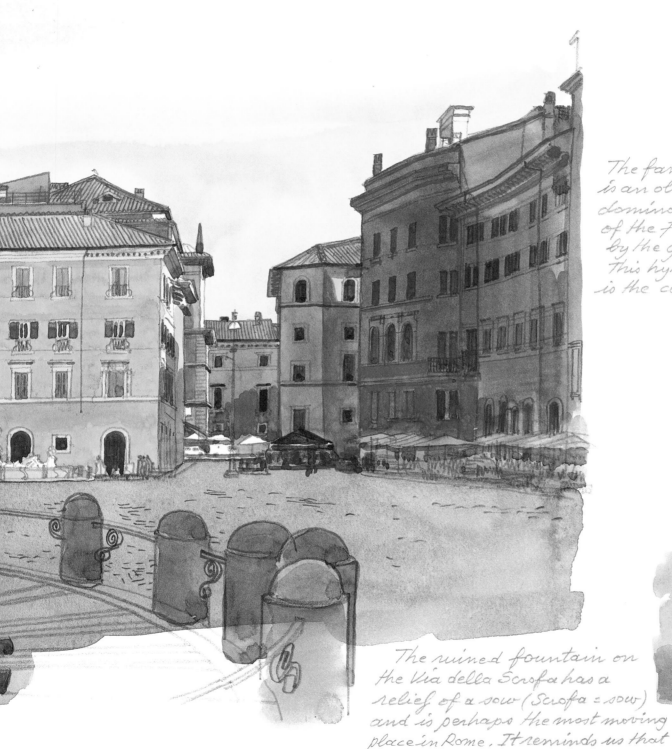

The famous Piazza Navona
is an old, oval-shaped arena
dominated by the Fountain
of the Four Rivers, created
by the genius of Bernini.
This hymn to water and stone
is the centre of the baroque city.

LIVELLO
DE CONDOTTI DEL
AQVA VERG.D ELL.
TRINITA DE MONTI

IN QUESTO LUOGO
ERA COLLOCATA
LA FONTANA
SPOSTATA SULL'ANGOLO
DI VIA DEI PORTOGHESI
NELL'ANNO 1874

The ruined fountain on
the Via della Scrofa has a
relief of a sow (Scrofa = sow)
and is perhaps the most moving
place in Rome. It reminds us that
the city was for a long time a village where domestic
animals, herds of cattle, sheep and pigs
wandered freely among the ruins.

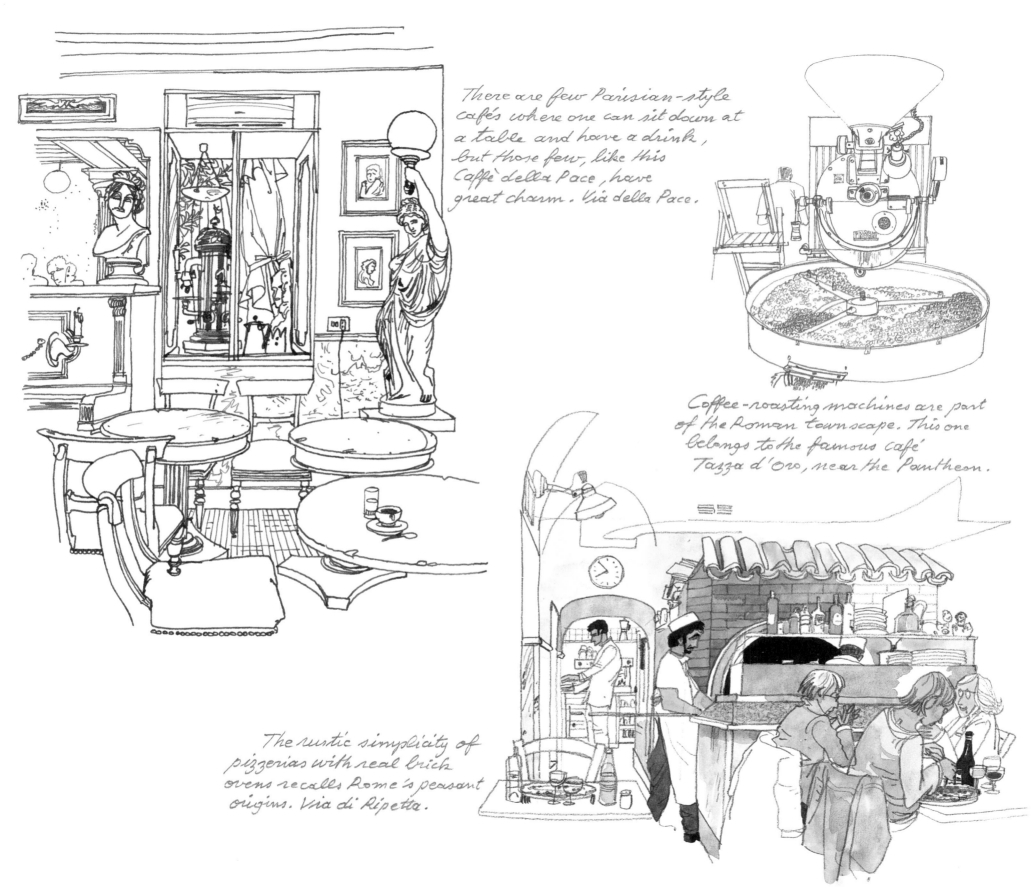

There are few Parisian-style cafés where one can sit down at a table and have a drink, but those few, like this Caffè della Pace, have great charm. Via della Pace.

Coffee-roasting machines are part of the Roman townscape. This one belongs to the famous café Tazza d'Oro, near the Pantheon.

The rustic simplicity of pizzerias with real brick ovens recalls Rome's peasant origins. Via di Ripetta.

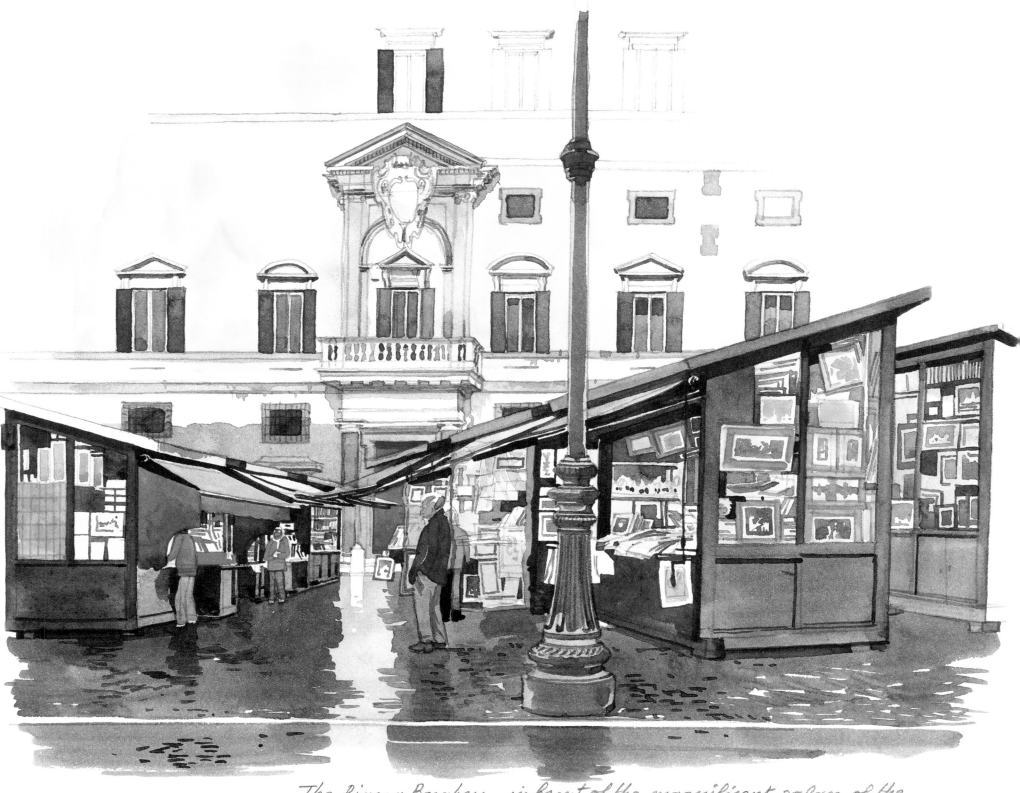

The Piazza Borghese, in front of the magnificent palace of the same name with coats of arms over its main balconied window – here one can find some of the city's few second-hand bookstalls and dealers in engravings and prints.

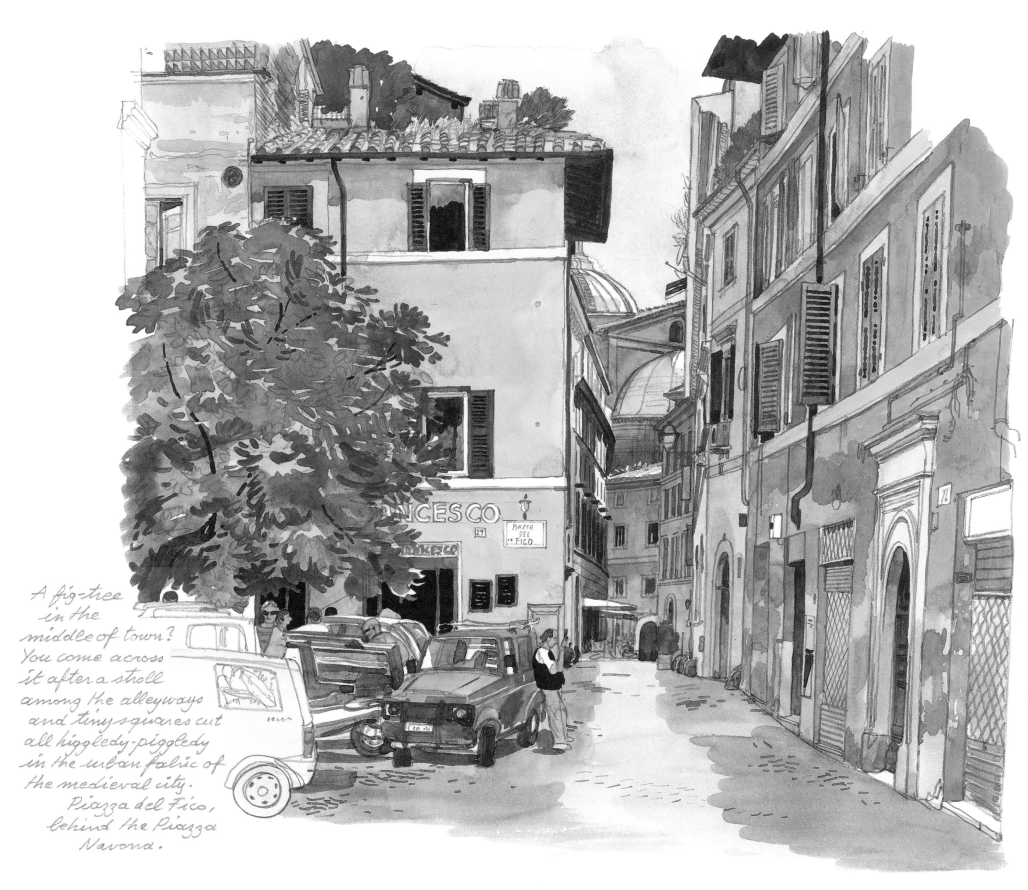

A fig-tree
in the
middle of town?
You come across
it after a stroll
among the alleyways
and tiny squares cut
all higgledy-piggledy
in the urban fabric of
the medieval city.
Piazza del Fico,
behind the Piazza
Navona.

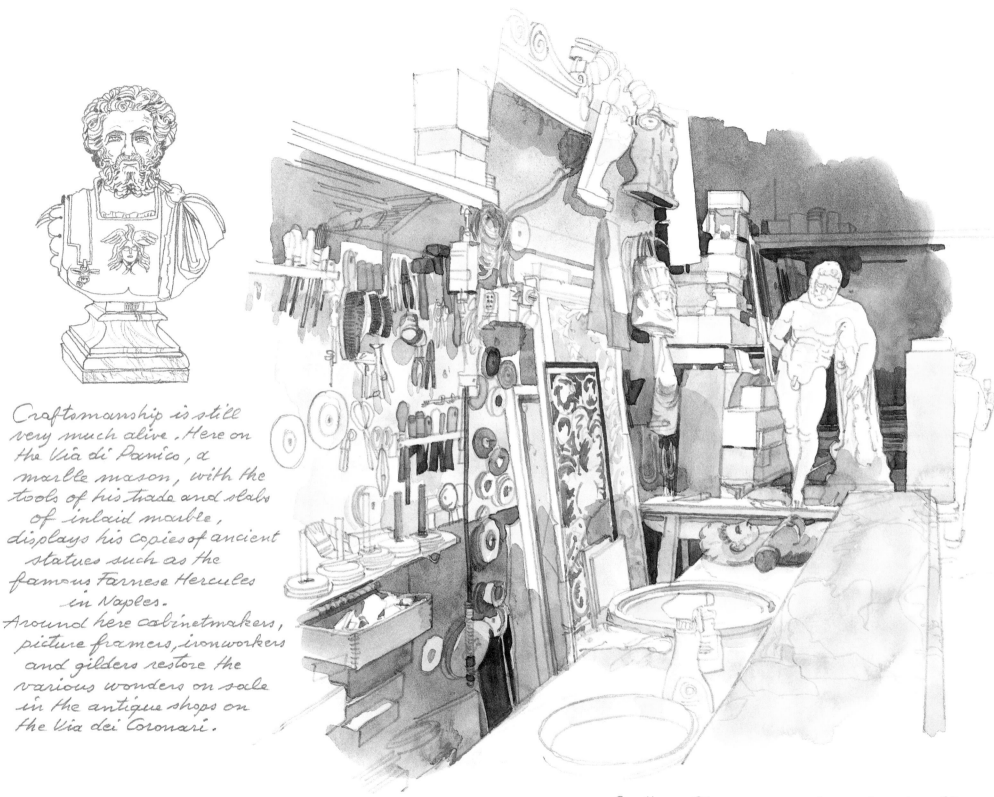

Craftsmanship is still
very much alive. Here on
the Via di Panico, a
marble mason, with the
tools of his trade and slabs
of inlaid marble,
displays his copies of ancient
statues such as the
famous Farnese Hercules
in Naples.
Around here cabinetmakers,
picture framers, ironworkers
and gilders restore the
various wonders on sale
in the antique shops on
the Via dei Coronari.

Campo dei Fiori

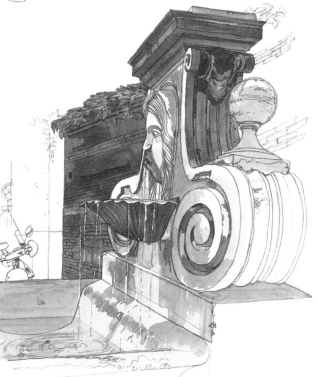

Nothing could be more practical than these three-wheelers for weaving in and out of the narrow streets in the area.

The Campo dei Fiori, a famous square where a daily market is held under the statue of Giordano Bruno, a monk burnt for pantheist heresy on 17th of February 1600. They sell everything - and one can also eat - in a pleasant popular atmosphere.

Not far from the Farnese arcade, the curious Fontana del Mascherone sings of the majestic calm of the Via Giulia, one of the most beautiful in Rome.

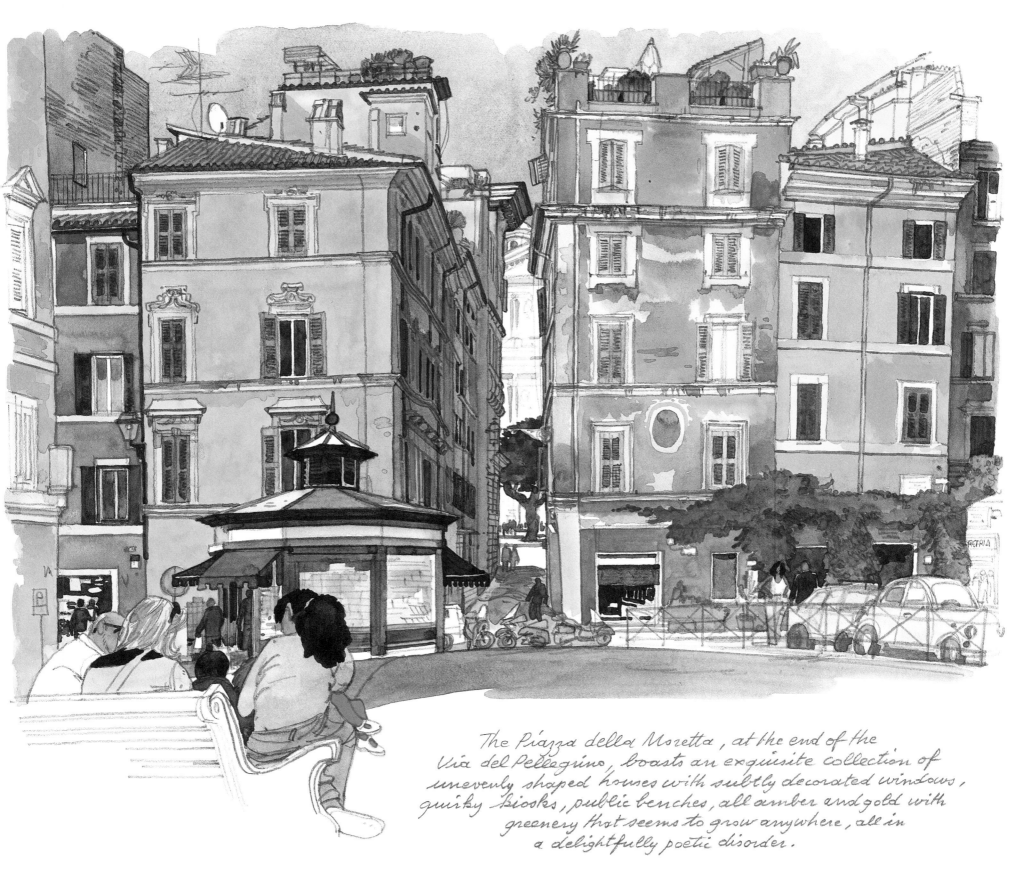

The Piazza della Moretta, at the end of the
Via del Pellegrino, boasts an exquisite collection of
unevenly shaped houses with subtly decorated windows,
quirky kiosks, public benches, all amber and gold with
greenery that seems to grow anywhere, all in
a delightfully poetic disorder.

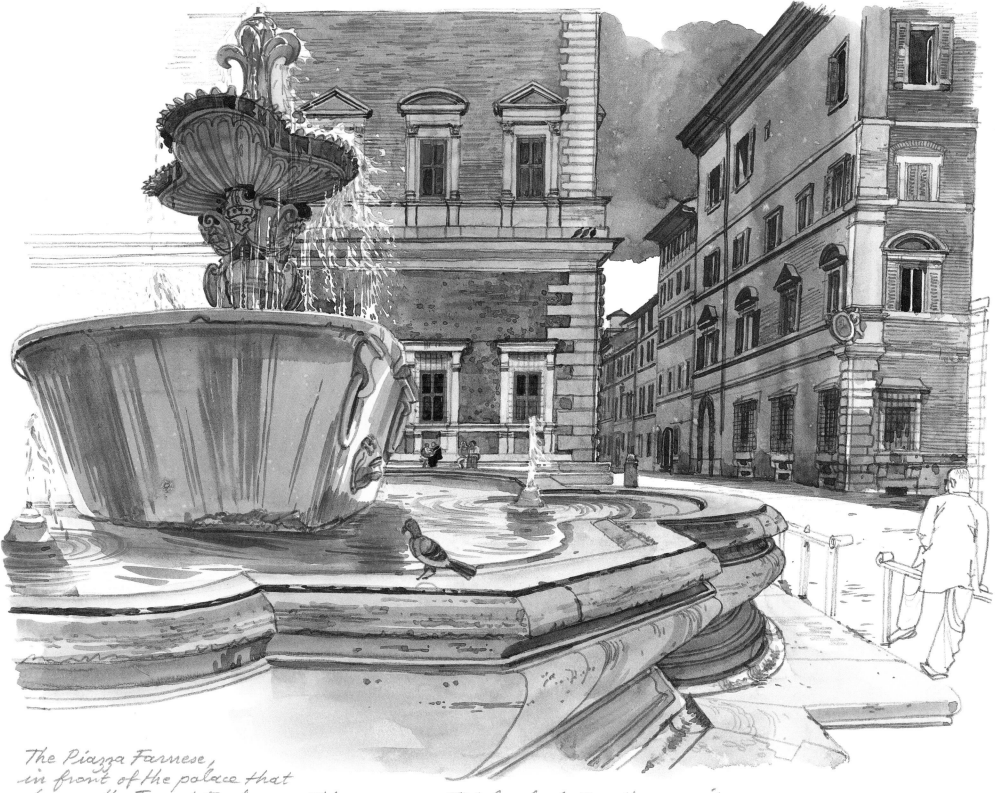

The Piazza Farnese, in front of the palace that houses the French Embassy. This monumental bowl of Egyptian granite, decorated with lion heads, was found in the baths of Caracalla. A lily has been added, symbol of the Farnese family.

The Piazza Santa Barbara, nestling in a hollow among houses, with, as always, a church in the background.
For generations, smart people have thronged to a restaurant in the square to savour the best cod fritters in the city.

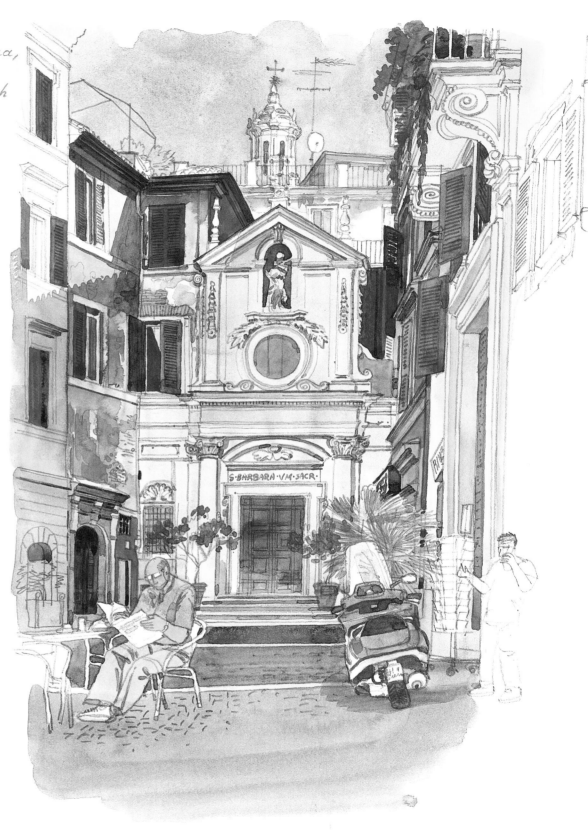

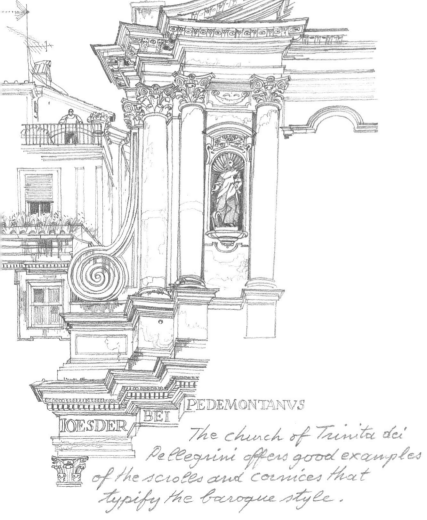

IOESDER BEI PEDEMONTANVS

The church of Trinità dei Pellegrini offers good examples of the scrolls and cornices that typify the baroque style.

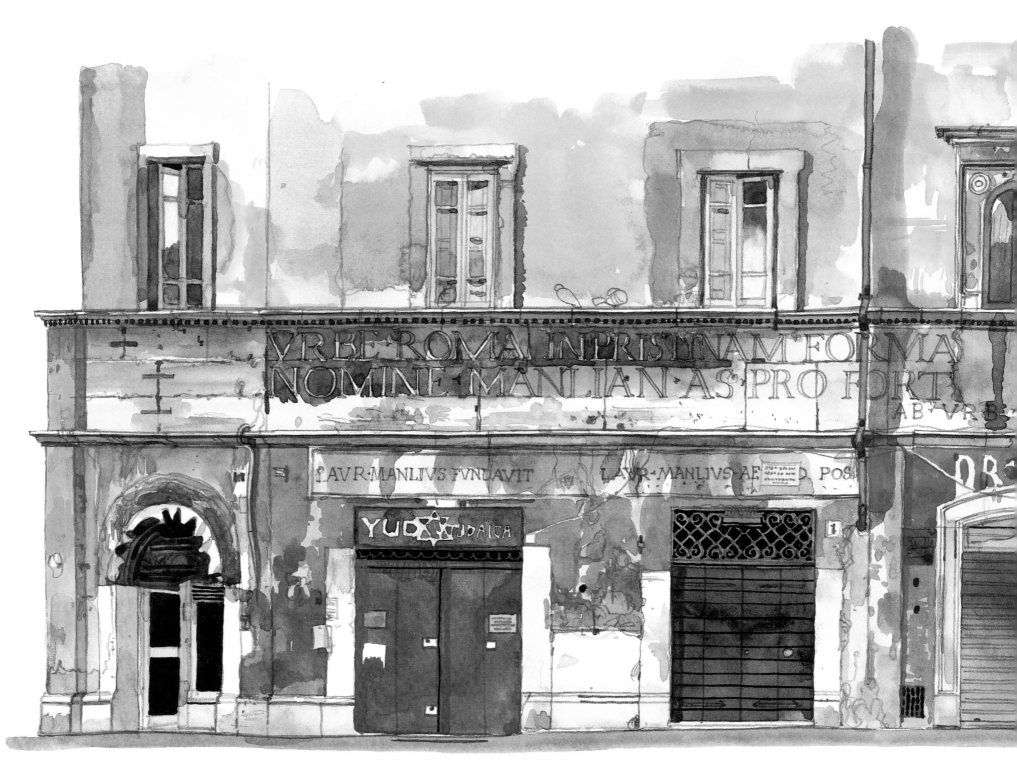

Ghetto

On the Via del Portico
d'Ottavia, Lorenzo Manilio,
an early lover of antiques,
decorated the house
he built here in 1468
with Roman bas-reliefs
and Latin inscriptions.

ENASCENTE·LAVR MANLIVS·RAR
AR·MEDIOCRI·TAT·A D·FOR·IVDEOR·SIB
N·M·M·CC·XXI·L'AN·M·I·III·D

Not far from the Tiber, along the
Via del Portico d'Ottavia, stretches
the old Roman ghetto where, for
three centuries, from the 16th to the
19th, the Popes obliged the Jews to live.
They were actually well treated,
apart from the obligation to live
there. Their culinary speciality
was deep-fried artichokes,
a delicious dish still
made there.

Another corner of the ghetto,
near the Palazzo Cenci, which, no
different from other districts of the city, is all
narrow, secretive streets, beautifully
coloured from yellow to
orange.

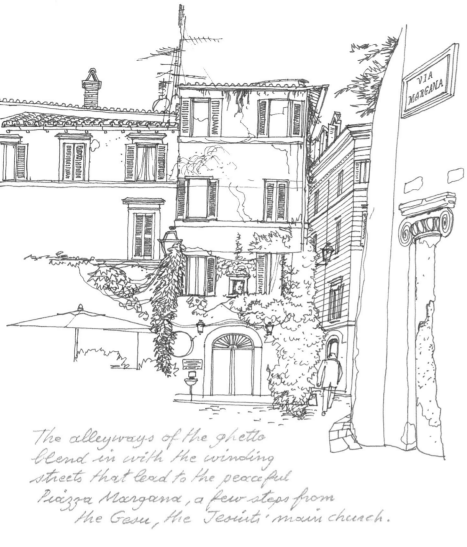

The alleyways of the ghetto
blend in with the winding
streets that lead to the peaceful
Piazza Margana, a few steps from
the Gesu, the Jesuits' main church.

The Fountain of the Tortoises is
one of the prettiest in Rome. It dates from
the 16th century. On the lower basin,
decorated with four huge shells, stand four
graceful epheles in the mannerist style
holding up with one hand the tortoises that
are busy drinking from the upper basin.
The fountain was designed
by Giacomo della Porta while Taddeo
Landini made the bronze figures.
The whole is so harmonious, so beautiful
that a baseless legend grew that
it was the work of Raphael.

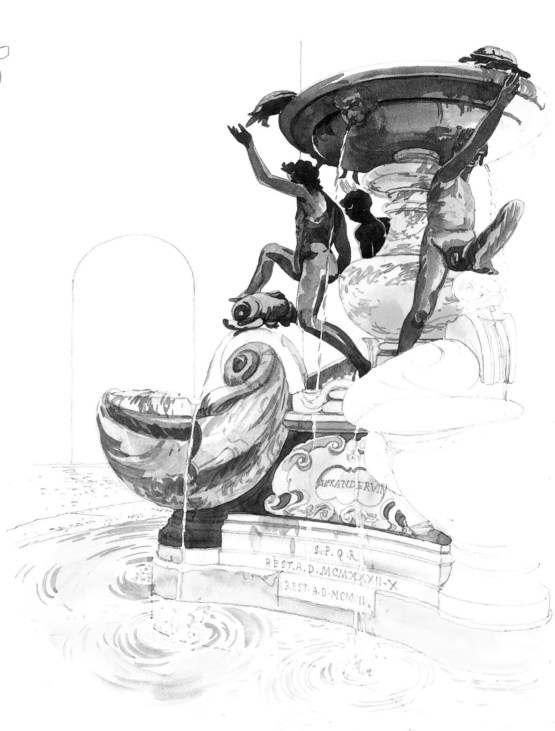

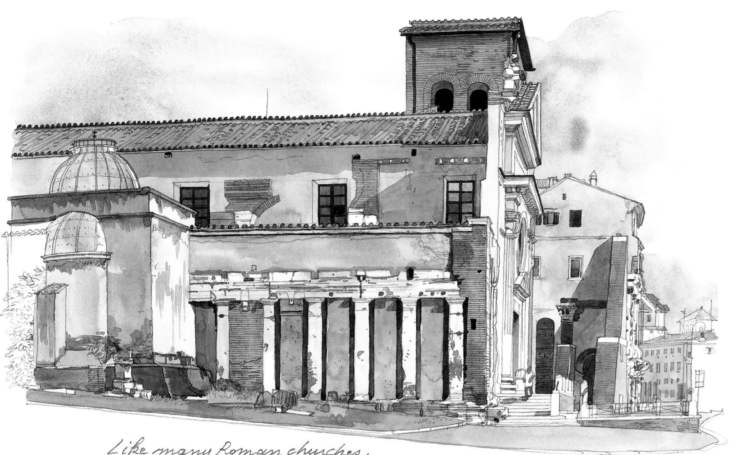

Like many Roman churches,
San Nicola in Carcere was built on the ruins of an ancient temple.
Why not re-use the sturdy colonnades of the places where the locals followed
their pagan practices?

Only ruins are left of the Portico
d'Ottavia, which was built by the Emperor
Augustus with loot from the Dalmatian wars,
and dedicated to his sister Octavia.
It was 115 metres long and housed
two libraries, a school and a
sculpture museum.

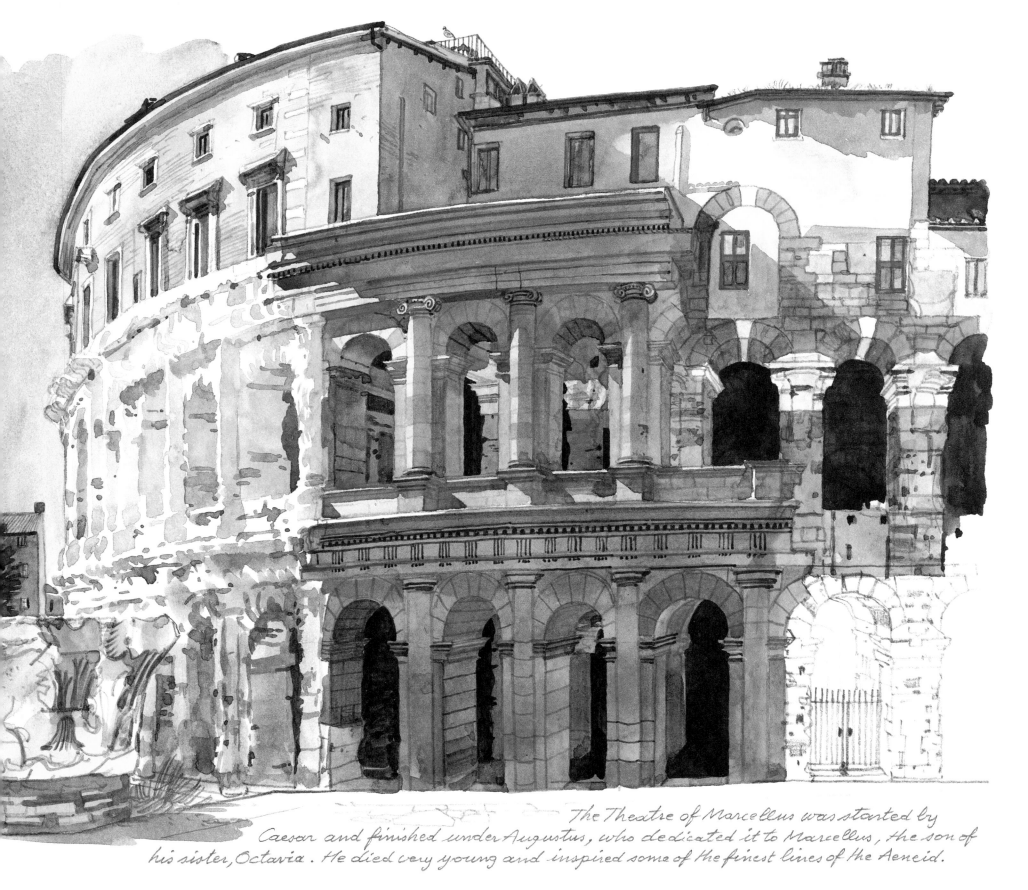

The Theatre of Marcellus was started by Caesar and finished under Augustus, who dedicated it to Marcellus, the son of his sister, Octavia. He died very young and inspired some of the finest lines of the Aeneid.

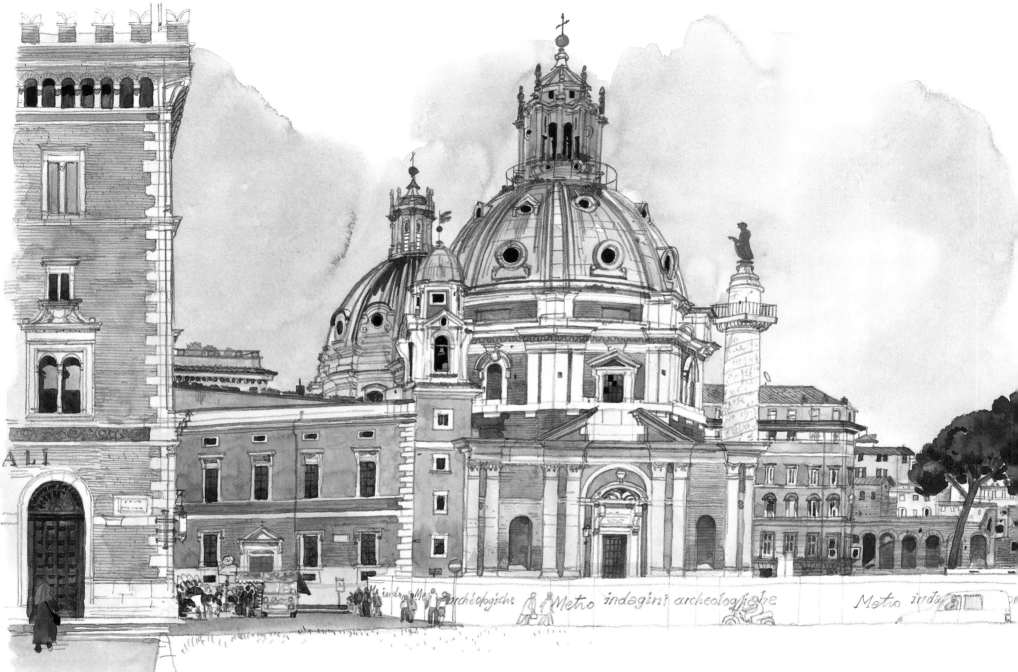

The Piazza Venezia, the geometric centre of the city, where the similar
but not identical churches of Santa Maria di Loreto and Santissimo Nome di
Maria face Trajan's column and the Imperial Forums.
On the opposite side, the Basilica di San Marco boasts
Giuliano da Maiano's fine portico. Here also is the palace used
by Mussolini to address the crowds from a balcony
overlooking the square.

Piazza Venezia

At the far end of the Piazza Venezia stands the Victor-Emmanuel monument, symbol of Italian unity, but so ugly that the Romans nicknamed it the typewriter.
Seen from the Vicolo Doria.

Nuns and priests in their religious clothes are becoming ever rarer, even in Rome.

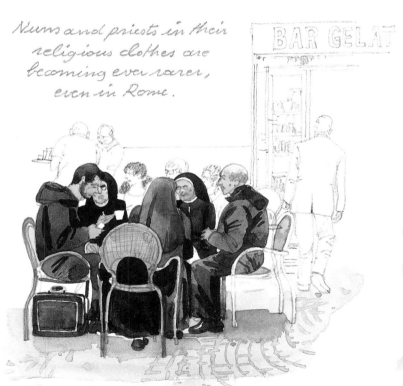

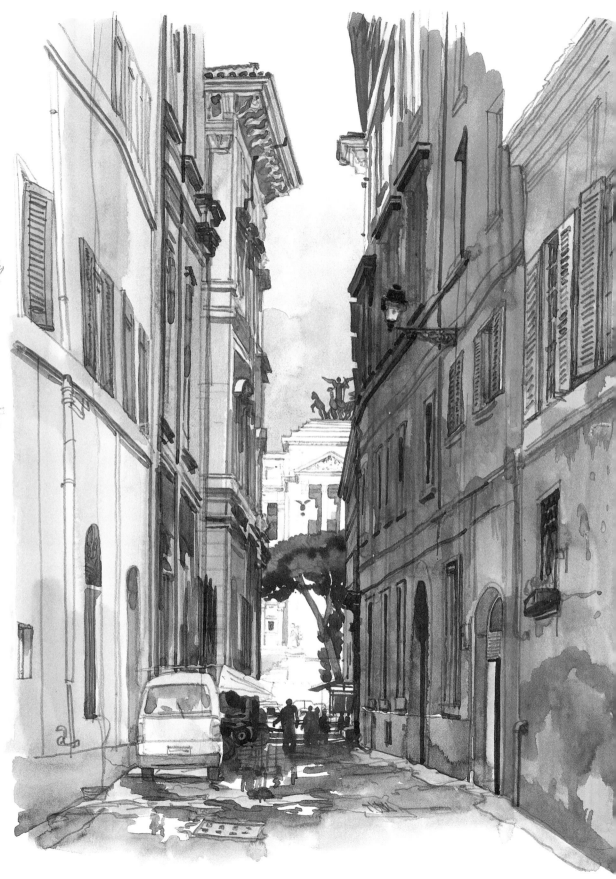

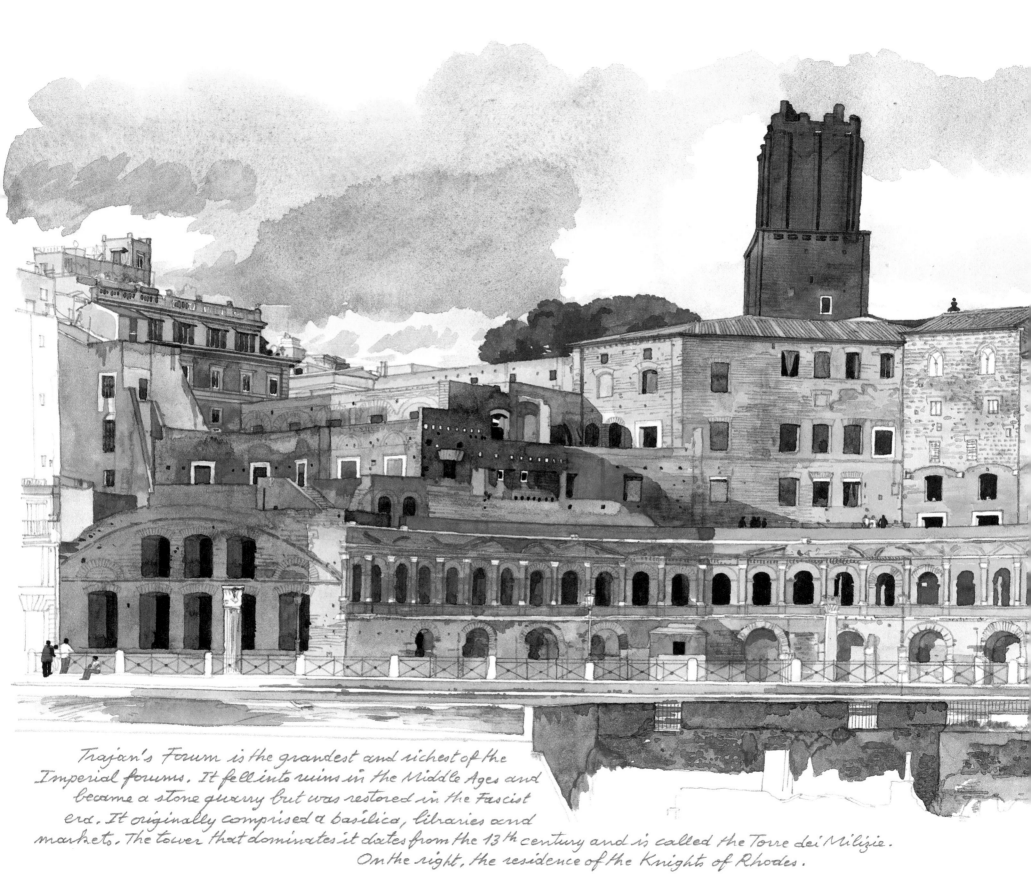

Trajan's Forum is the grandest and richest of the
Imperial forums. It fell into ruins in the Middle Ages and
became a stone quarry but was restored in the Fascist
era. It originally comprised a basilica, libraries and
markets. The tower that dominates it dates from the 13th century and is called the Torre dei Milizie.
On the right, the residence of the Knights of Rhodes.

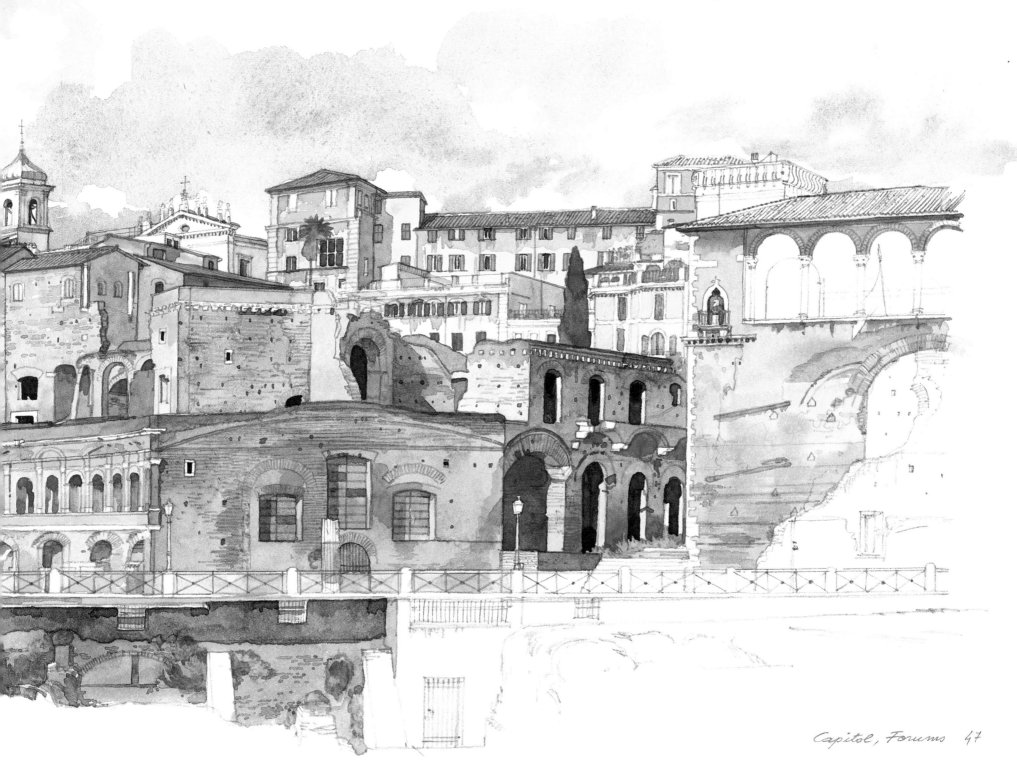

Capitol, Forums

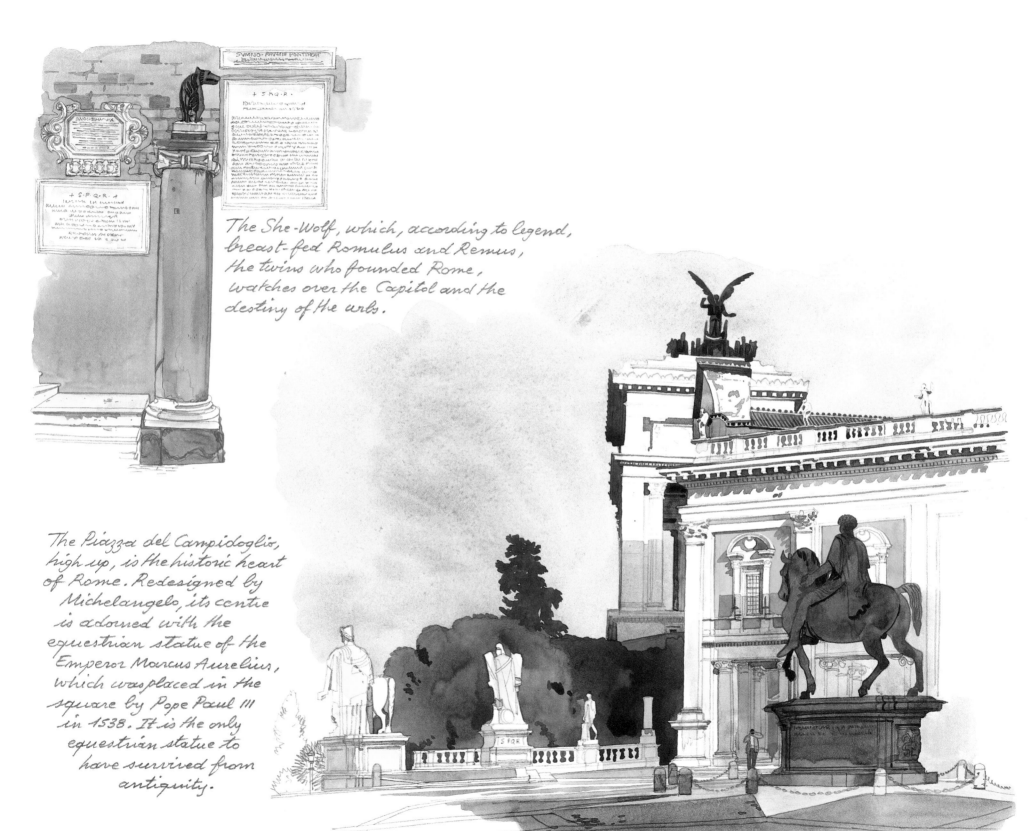

The She-Wolf, which, according to legend, breast-fed Romulus and Remus, the twins who founded Rome, watches over the Capitol and the destiny of the urbs.

The Piazza del Campidoglio, high up, is the historic heart of Rome. Redesigned by Michelangelo, its centre is adorned with the equestrian statue of the Emperor Marcus Aurelius, which was placed in the square by Pope Paul III in 1538. It is the only equestrian statue to have survived from antiquity.

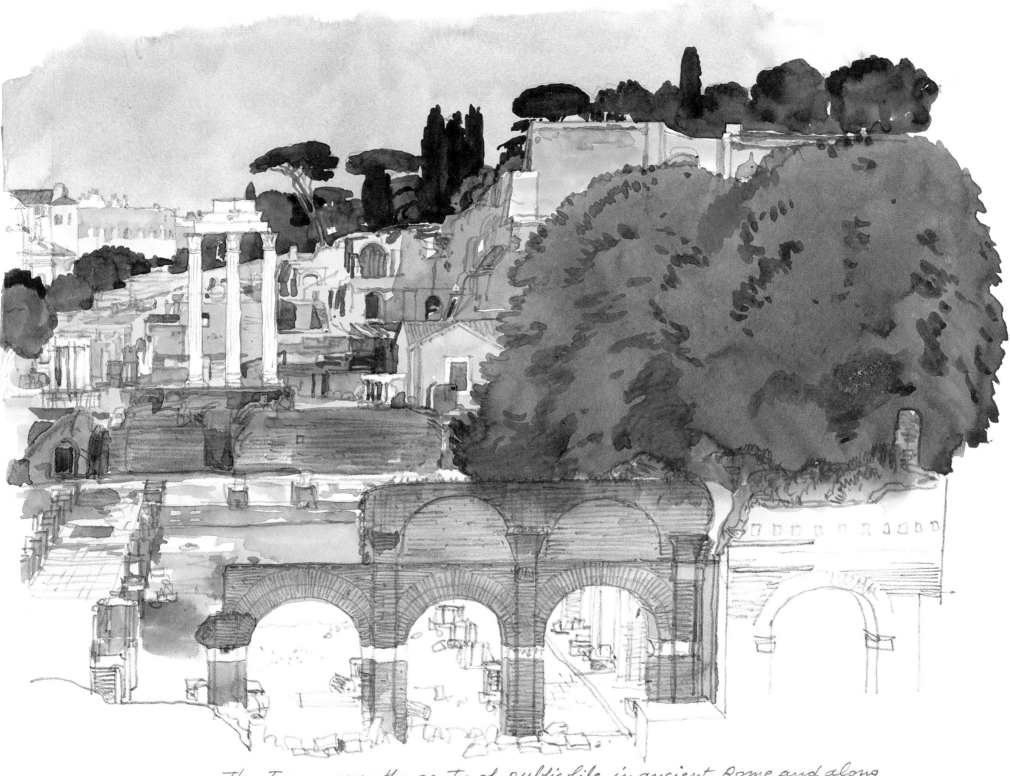

The Forum was the centre of public life in ancient Rome and along
its paved roads it brought together temples, basilicas and triumphal arches
whose ruins now mingle poetically with abundant greenery.

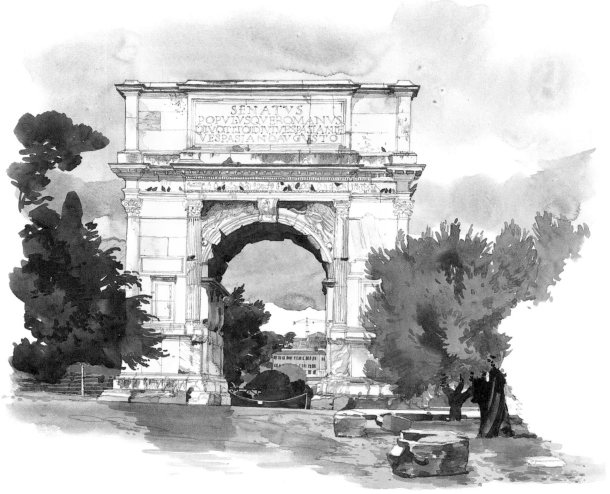

The Arch of Titus, at the end of the Forum,
was built at the time of Domitian
by the Senate to commemorate the war against
the Jews that was started by Vespasian and
ended with the destruction of Jerusalem in
70 AD. The Latin inscription carved at the top of
the triumphal arch recalls the event.

The Via Sacra that
crosses the Forum is
lined with sanctuaries
and leads from the Temple of
Romulus to that of Julius Caesar.
The three tall Corinthian
columns in the centre are
all that remain of the
Temple of the Dioscuri,
headquarters of the
Imperial bureau for weights
and measures.

This jumble of ancient
ruins and Christian churches,
littered with broken columns,
is one of Rome's pleasantest
promenades.
The Temple of Saturn and
the Arch of Septimius Severus
seen from the Via della
Consolazione.

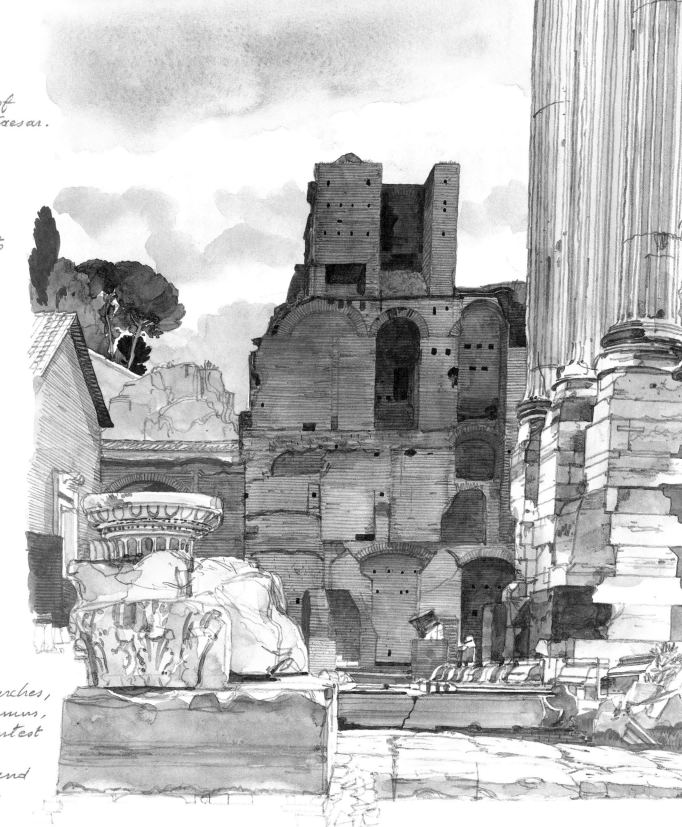

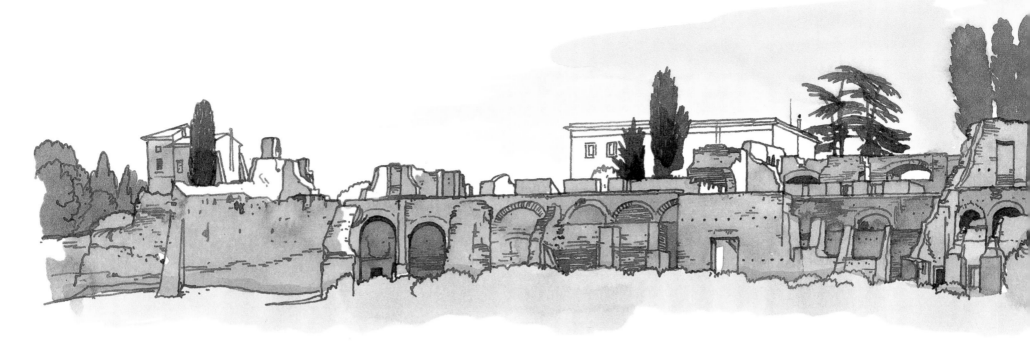

The Celio, one of the seven hills, was overrun by buildings from Nero's time because of its proximity to the Palatine, and later by Christian churches, such as the Church of San Tommaso in Formis, built between the piles of the Claudian aqueduct.

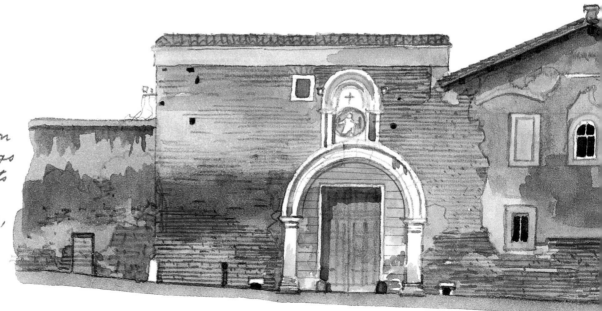

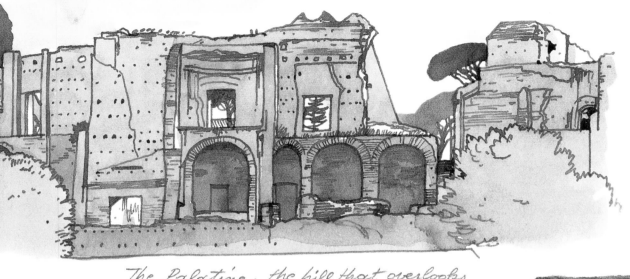

The Palatine, the hill that overlooks
the Forum and the Circus Maximus, was home
to the palaces of the emperors, in particular those
of Augustus, Tiberius and Septimius
Severus, as well as a huge stadium built
by Domitian.

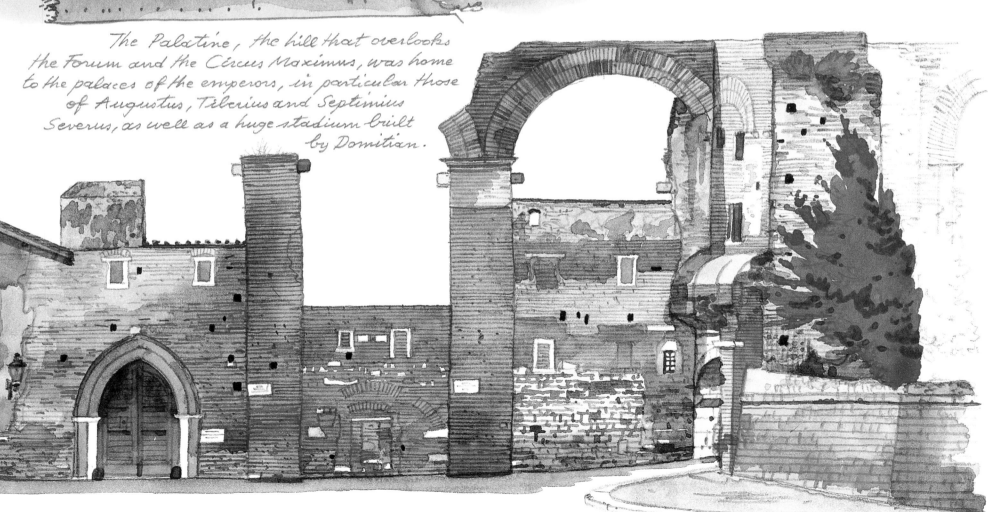

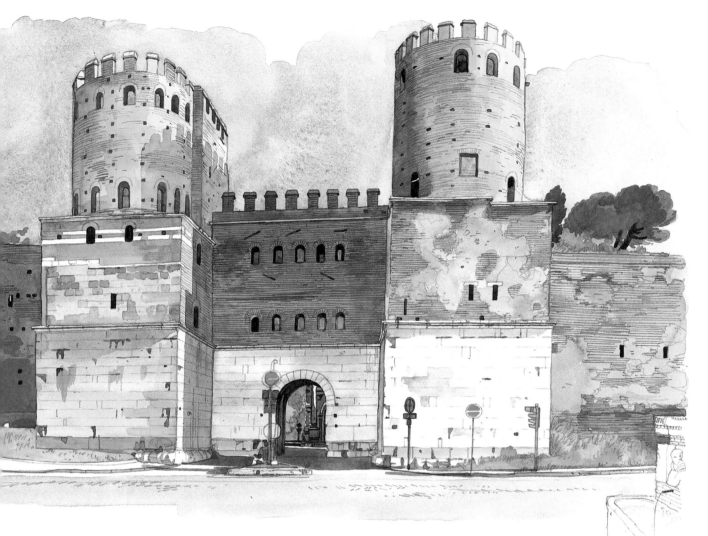

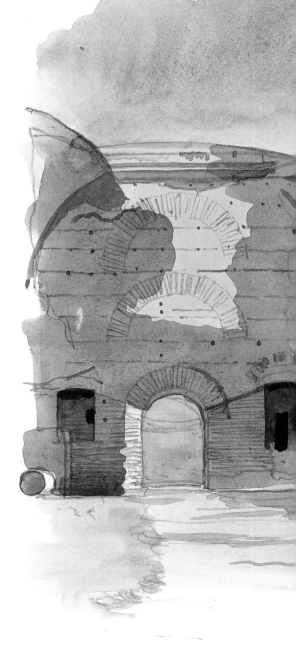

The Porta San Sebastiano, with its majestic architecture, crenellated towers and marble facings, opened access through the ramparts to the Via Appia Antica.

The baths of Caracalla, where excavations were particularly fruitful, were the most grandiose. Marbles, columns, mosaics, stucco and statues, now vanished (or re-used elsewhere) once decorated the ruined walls we see today. Apart from the construction of the gigantic baths, Caracalla's other claims to fame were the assassination of his brother and joint-emperor, Geta, and his grant of Roman citizenship to all free people of the Empire.

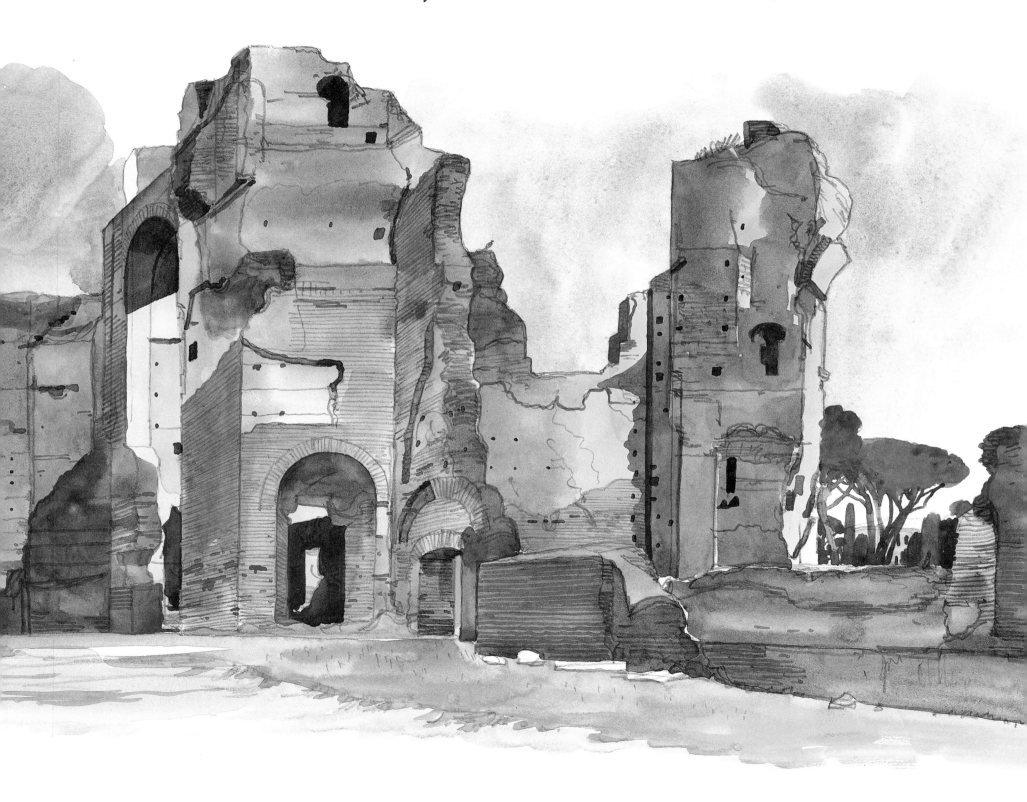

Baths of Caracalla, Via Appia Antica

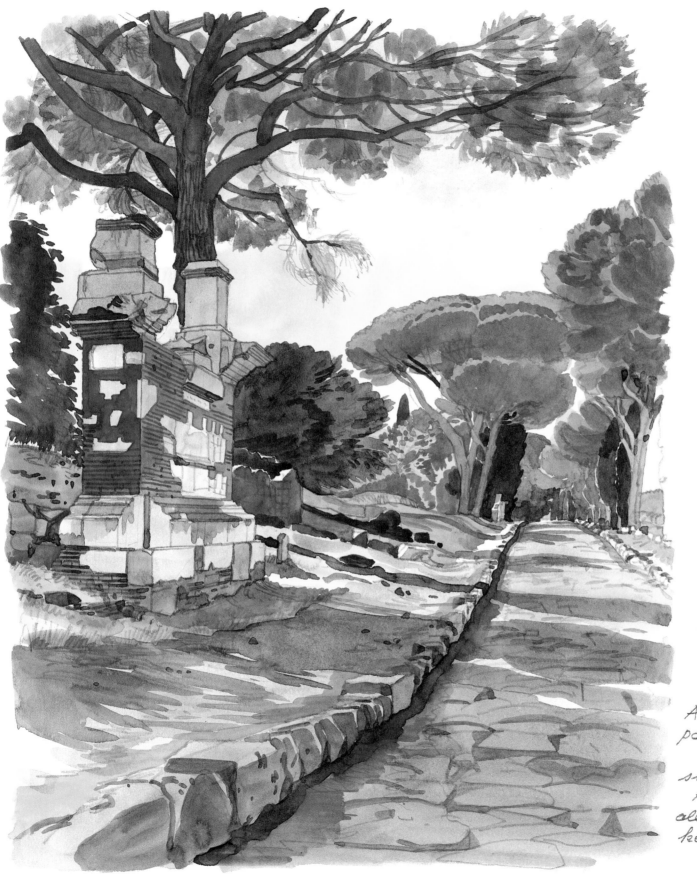

C·RABIRIVS·POSTL·RABIRIA·VSIA·PRIMA·SAC
HERMODORVS · DEMARIS · ISIDIS

A·AEMILIVS·A·L

VALERIVS

AEMILIA

VALERIA

A road that has kept its Roman
paving, antique stelae,
fragments of walls and
statues, umbrella pines –
the Via Appia Antica retains
all the rural melancholy so
keenly felt by Chateaubriand.

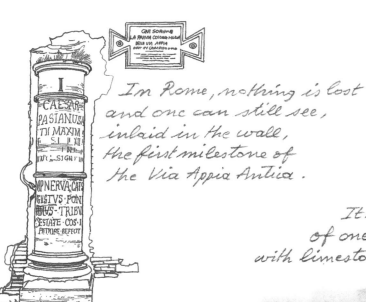

In Rome, nothing is lost
and one can still see,
inlaid in the wall,
the first milestone of
the Via Appia Antica.

On the Via Appia Antica, which went from Rome to
Naples, is a cylindrical tower of twenty metres diameter.
It is the tomb of Cecilia Metella, a great lady, daughter-in-law
of one of Caesar's generals. This imposing mausoleum, still faced
with limestone, was used as a fortress in the Middle Ages.

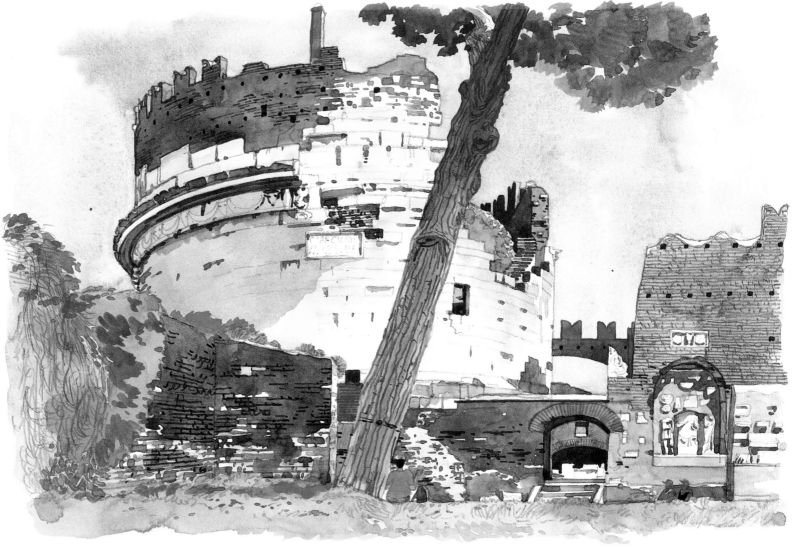

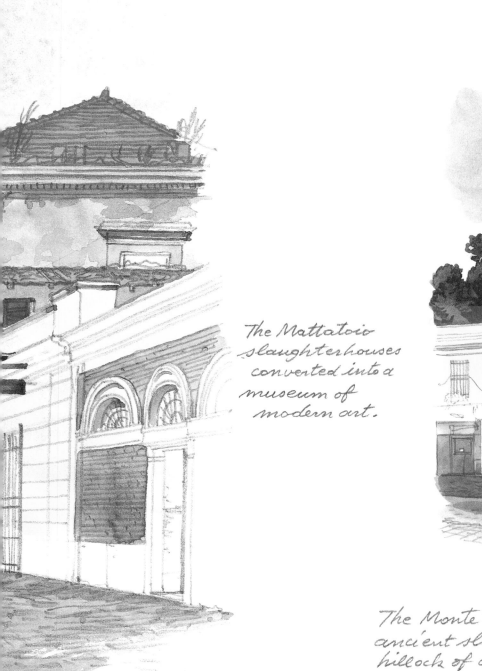

The Mattatoio
slaughterhouses
converted into a
museum of
modern art.

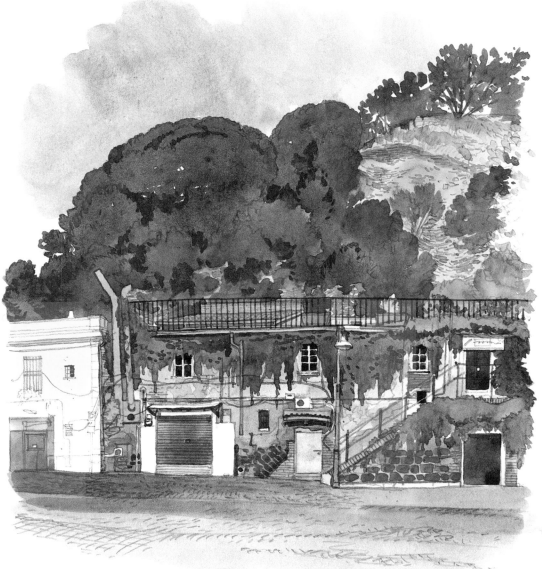

The Monte Testaccio, at whose foot stood
ancient slaughterhouses, is a half-abandoned
hillock of amphora fragments on the bank of
the Tiber, now only frequented by
boys up to no good.

A museum of antique
sculpture has been set up
in a disused power
station on the Via Ostiense,
keeping its industrial
machinery — it makes for
an evocative confrontation
between the ancient
and modern.

Working-class blocks have
a certain allure in Rome,
thanks to the colour of the walls
which avoid the grey and dingy
tones more usual in this type of housing.
La Garbatella, much loved by the film maker
Nanni Moretti, is these days a very agreeable place
to live in.

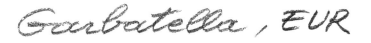

One of the *Fascists'* better
achievements is EUR,
the *"Esposizione Universale
di Roma"*. This district was
built for the
Universal Exhibition
of 1942, cancelled
because of the war.
De Chirico–style
metaphysical palaces
are everywhere as are
statues that recall
the grandeur of the
Roman Empire.
The *Palazzo della
Civilta del Lavoro*, a
"square Colosseum".

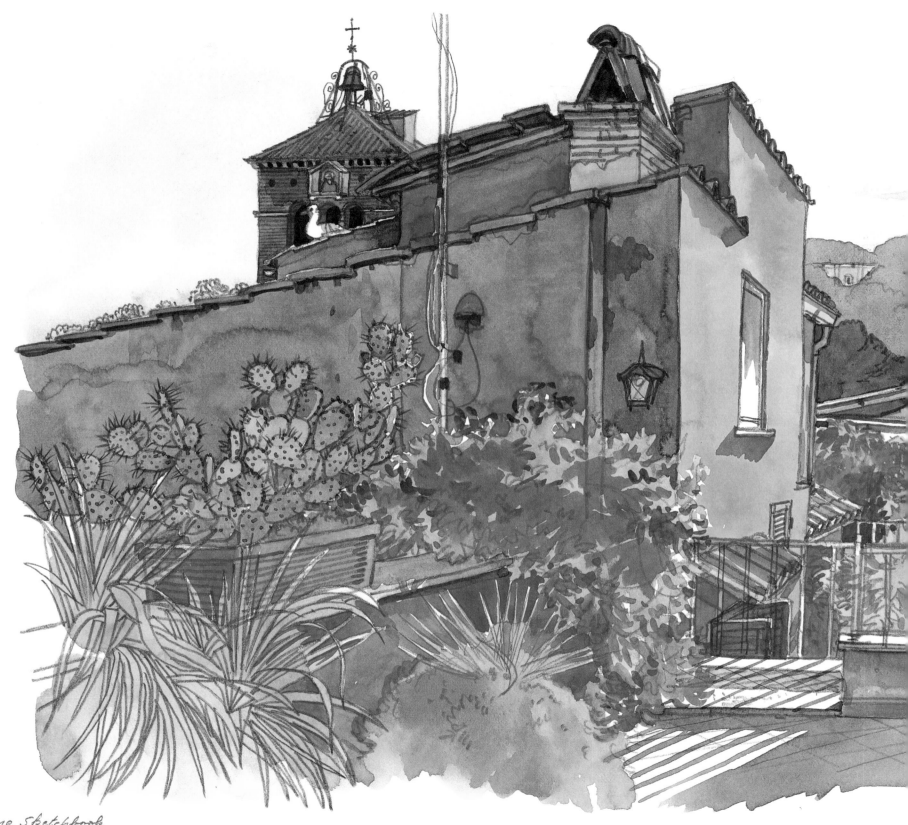

Trastevere

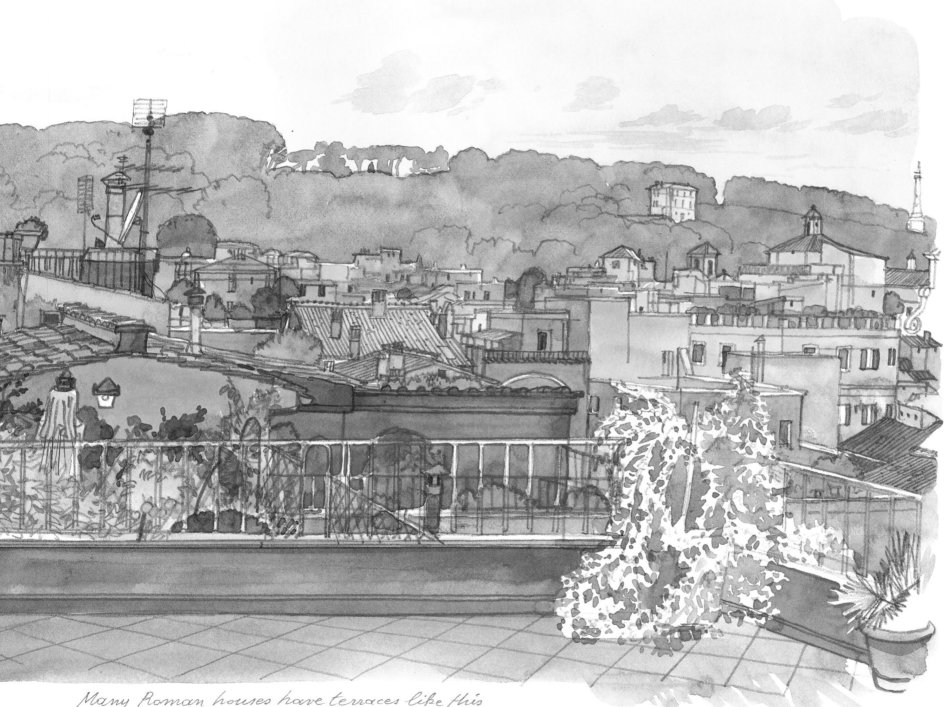

Many Roman houses have terraces like this
with magnificent views of Trastevere and
the Janiculum.

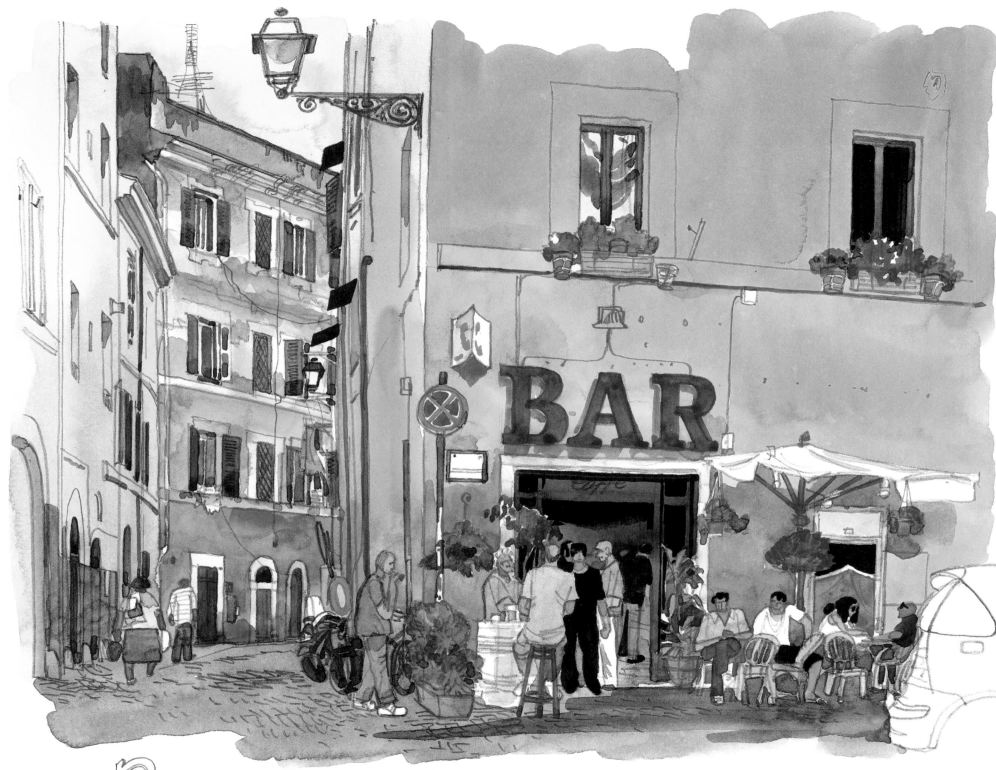

Bar

In Trastevere, there are still some working-class bars where men meet to chat amongst themselves over a coffee, in the old Mediterranean manner. The woman can only be a tourist.

All the old "Trasteverini" know the best places for dried pig's cheek, ricotta, pecorino, olive oil and pasta, items essential for cooking their favourite dishes. One can still find shops in Trastevere that display these wonders with their picturesque old names.

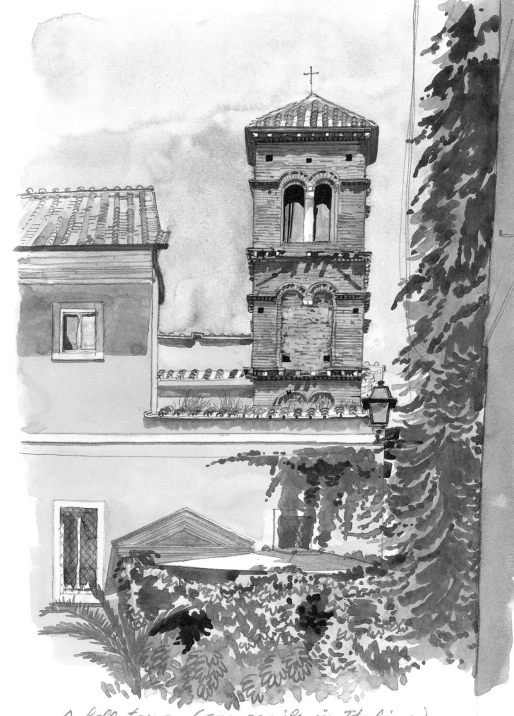

A bell tower (campanile in Italian) with elegantly gemelled Romanesque windows appears unexpectedly in dense foliage on the Via della Lungaretta, a bustling street in Trastevere.

The Paola Fountain, erected in 1612
on the orders of Paul V, with marble taken
from the Forum, is the most majestic
of public fountains with its six Doric
columns supporting the inscribed
dedication.

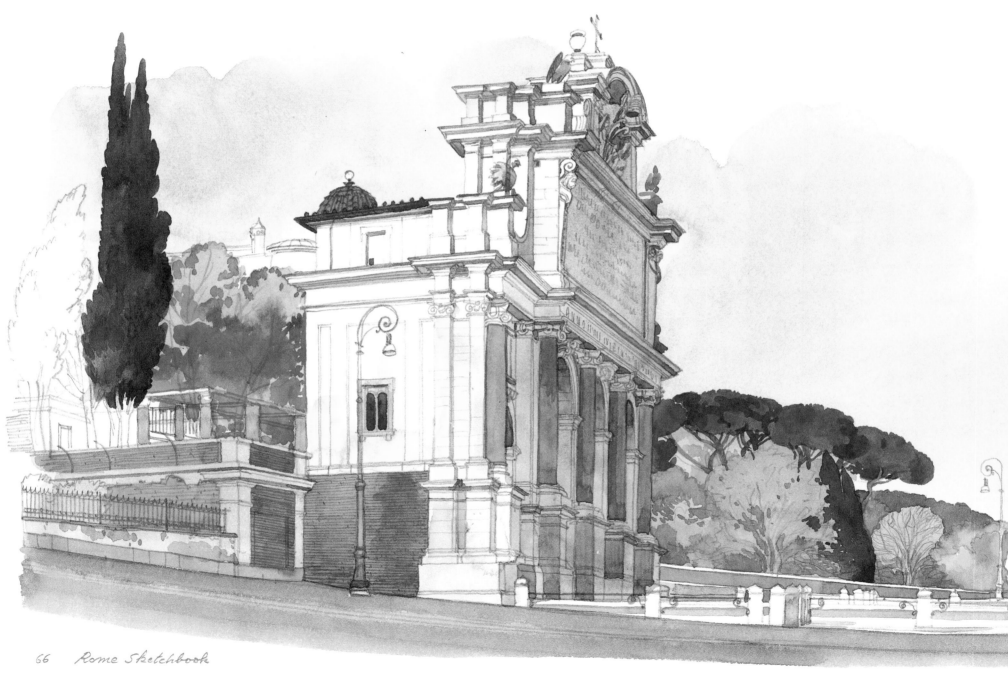

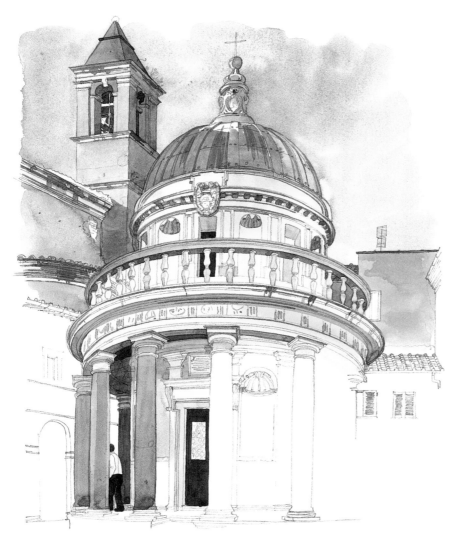

On the Janiculum is the Tempietto
by the great architect Bramante, a
little circular edifice supported
by sixteen granite columns, a perfect
example of Renaissance art. Bramante
was not able to construct the circular cloister
that he wanted as the setting for his "little temple".

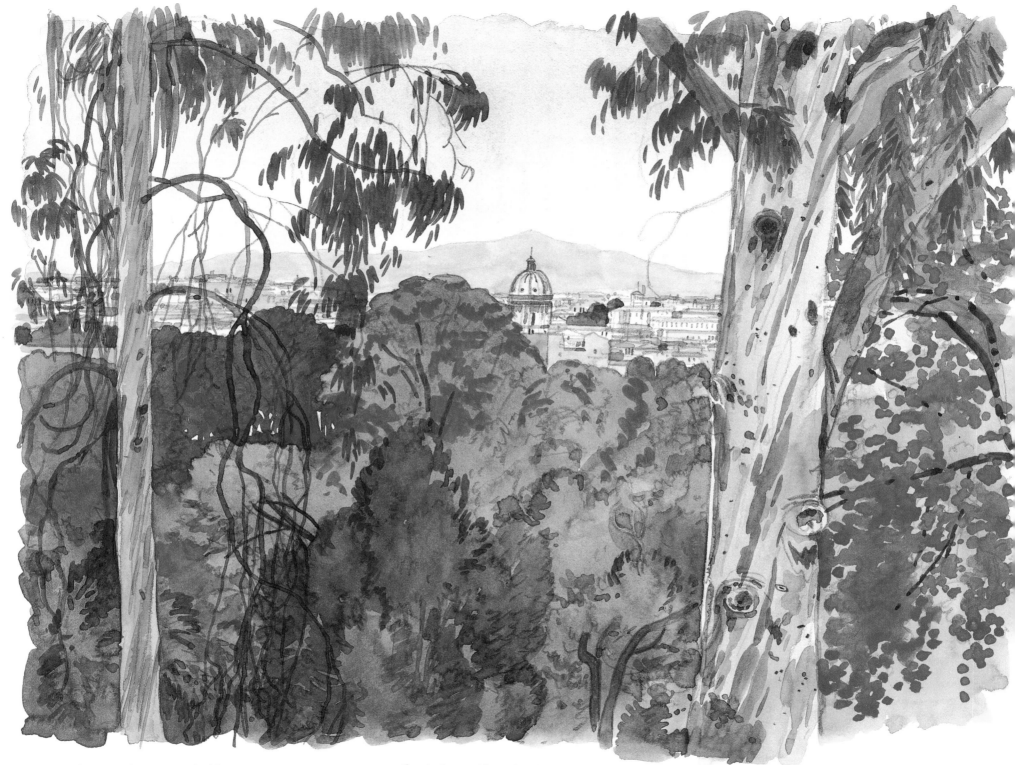

On the slopes of the Janiculum hill behind the Palazzo Corsini,
the Botanical Gardens display a great variety of harmoniously laid out
plants and trees. One can just make out the city and the Sabine hills
through the eucalyptus trees.

The Via Sant' Onofrio on
the Janiculum is dear to
all readers of Tasso, the
melancholic poet who lived
in the neighbourhood and
died in the monastery of
the same name.

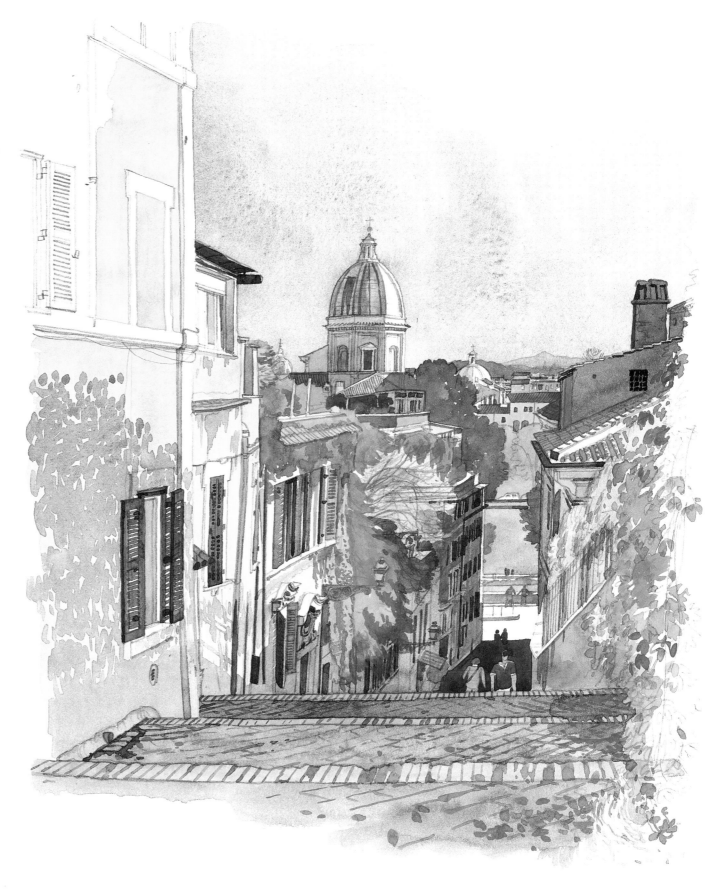

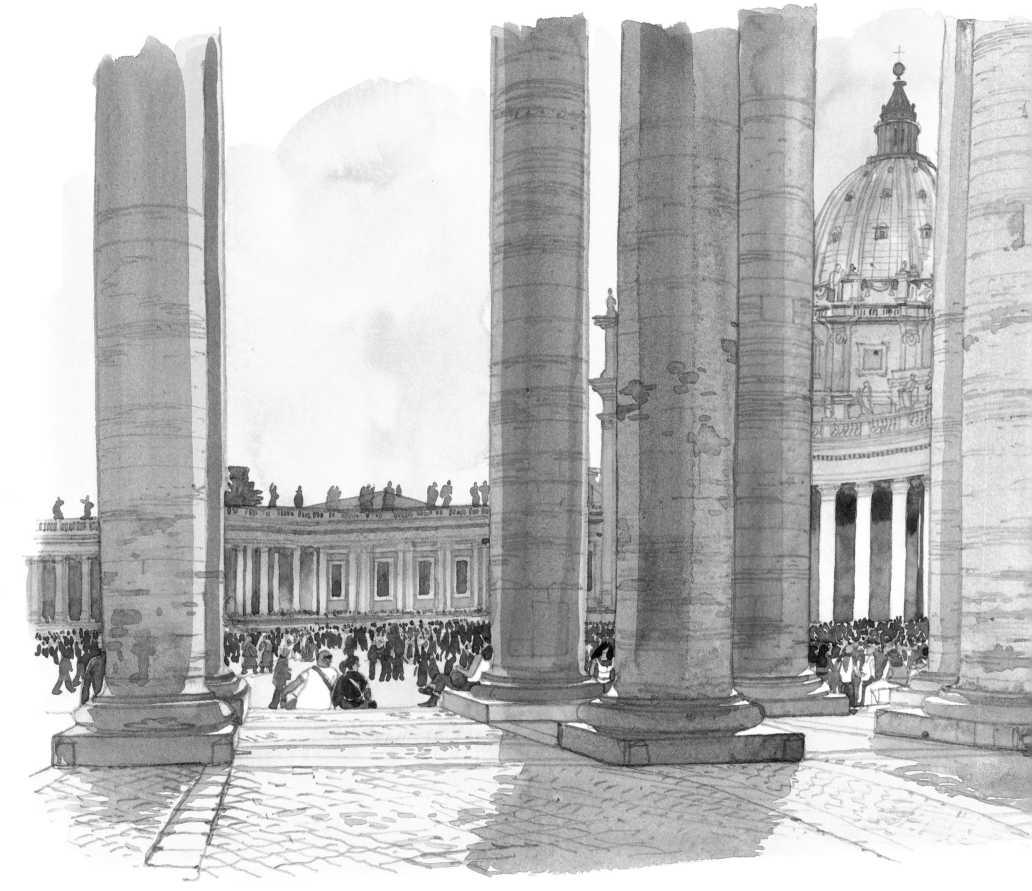

St Peter

Through Bernini's famous, giant colonnade laid out to look like arms open to receive the whole Christian world, one can see the dome of St Peter's, Michelangelo's masterwork, and the crowd that enlivens the great square at all hours. Pilgrims congregate here, as do many tourists, and the souvenir shops thrive.

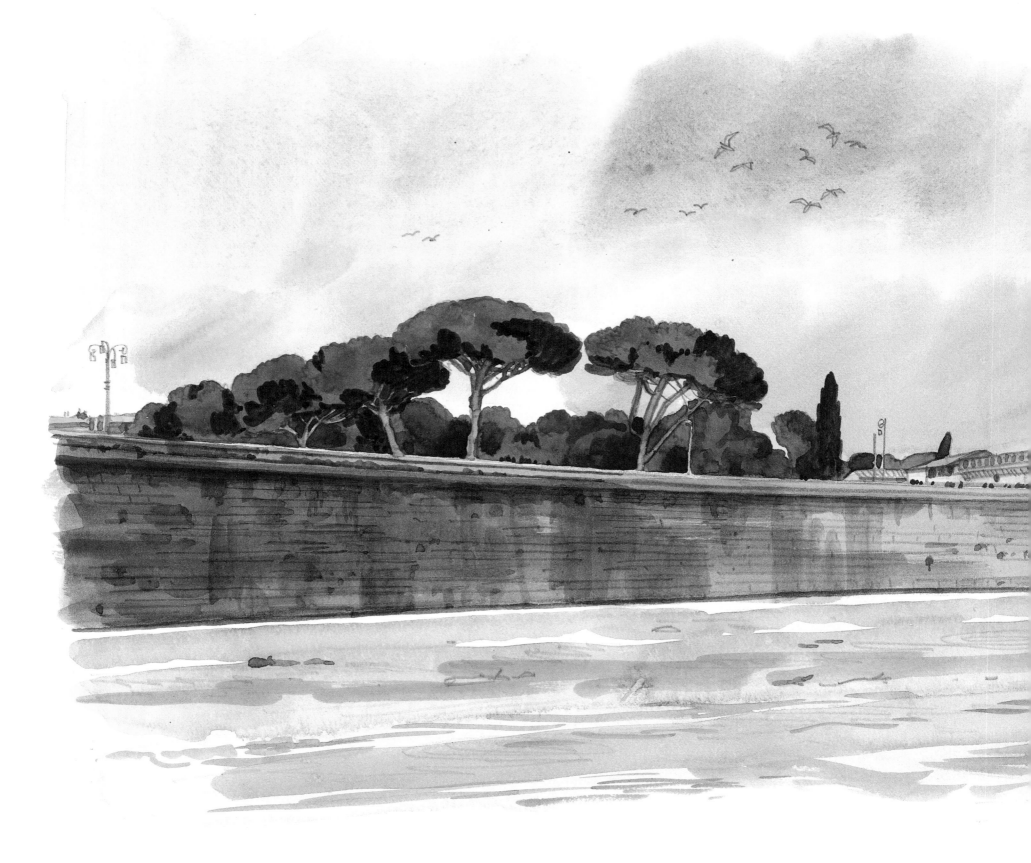

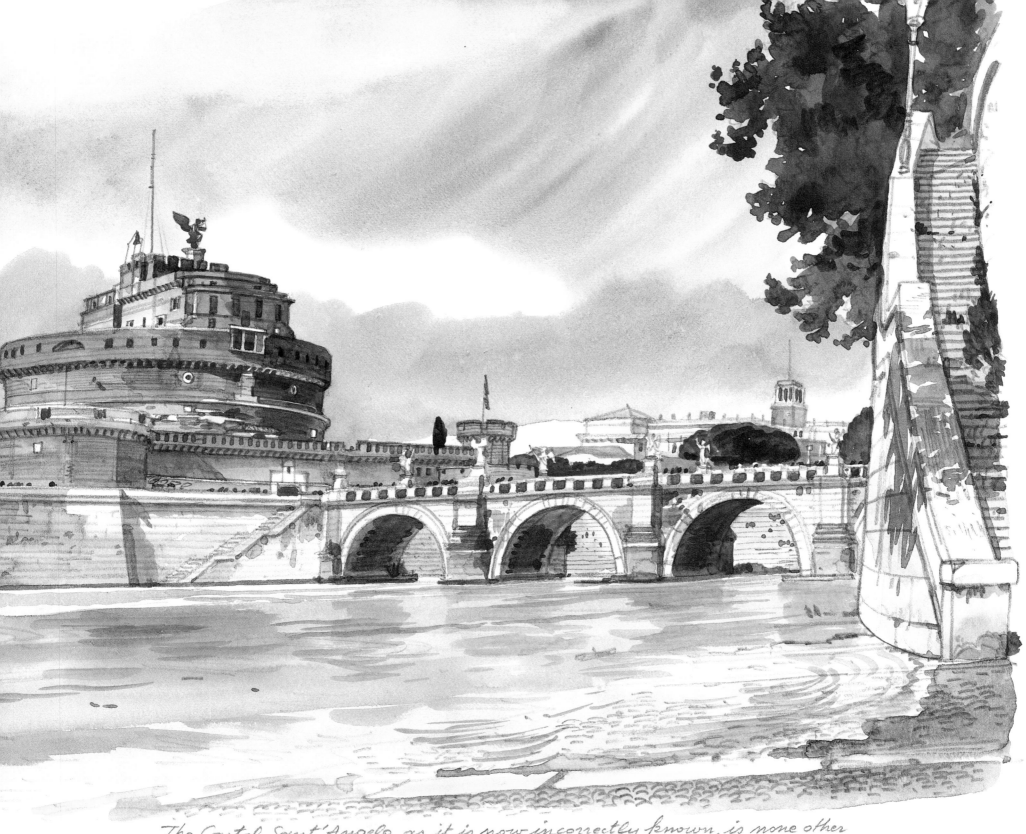

The Castel Sant'Angelo, as it is now incorrectly known, is none other than the mausoleum the Emperor Hadrian built for himself.

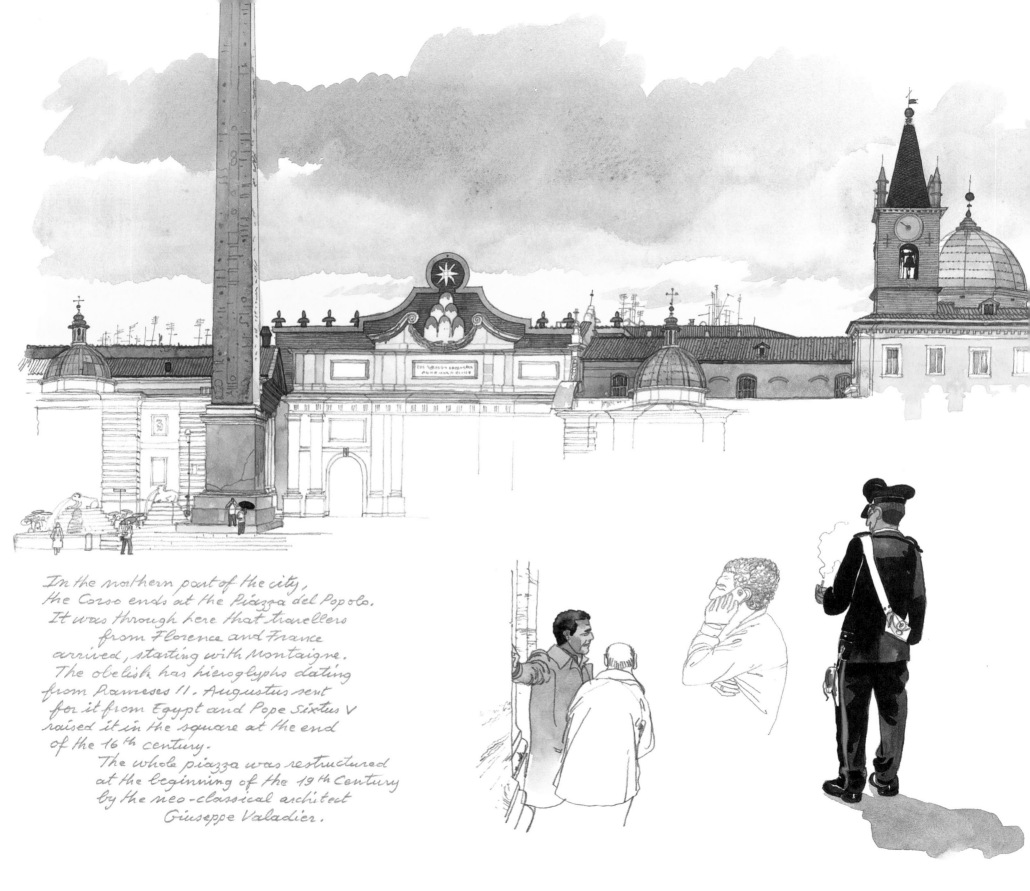

In the northern part of the city,
the Corso ends at the Piázza del Popolo.
It was through here that travellers
 from Florence and France
arrived, starting with Montaigne.
 The obelisk has hieroglyphs dating
from Rameses 11. Augustus sent
 for it from Egypt and Pope Sixtus V
raised it in the square at the end
 of the 16th century.
 The whole piazza was restructured
 at the beginning of the 19th Century
 by the neo-classical architect
 Giuseppe Valadier.

Piazza del Popolo

The medieval church
of Santa Maria del Popolo,
in the Piazza del Popolo,
remodelled in the 15th
century on the orders of
Sixtus IV, contains great art
treasures: saints and angels
by Bernini on the arches,
statues by Bernini and
Lorenzetto in the Chigi
Chapel, a fresco by
Pinturicchio and two
magnificent paintings
by Caravaggio, The Ecstasy
of St Paul, with the great
white horse, and The
Crucifixion of St Peter.

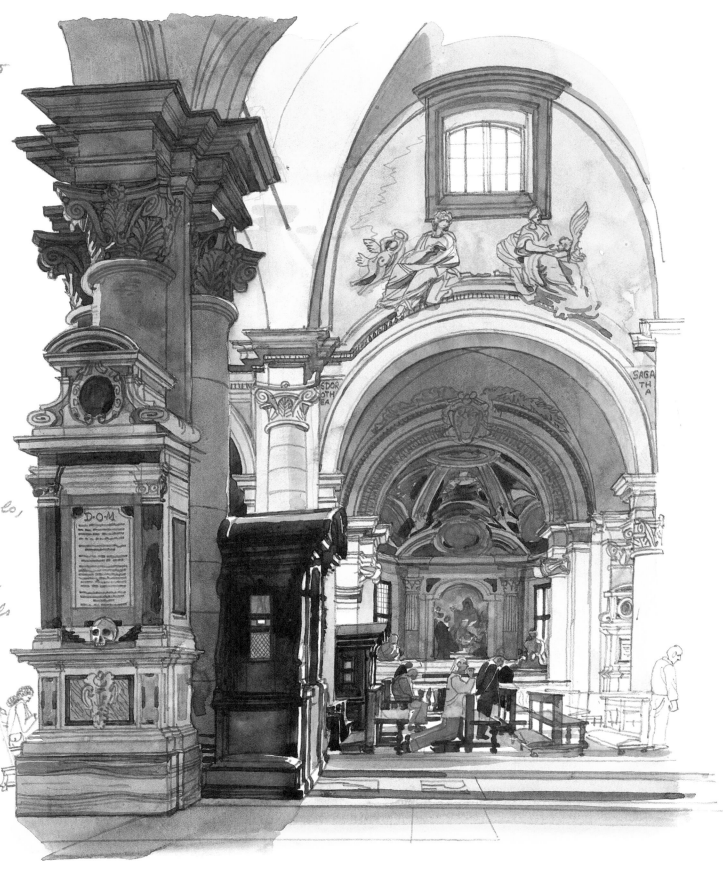

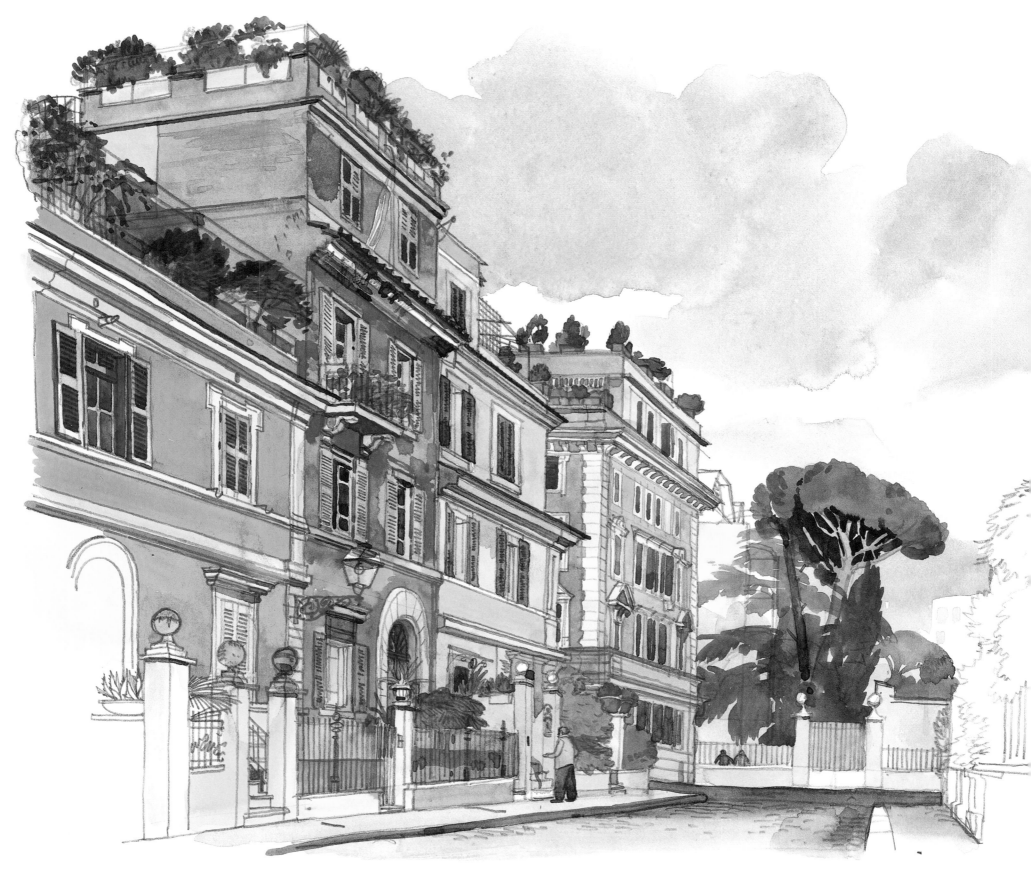

Foro Italico

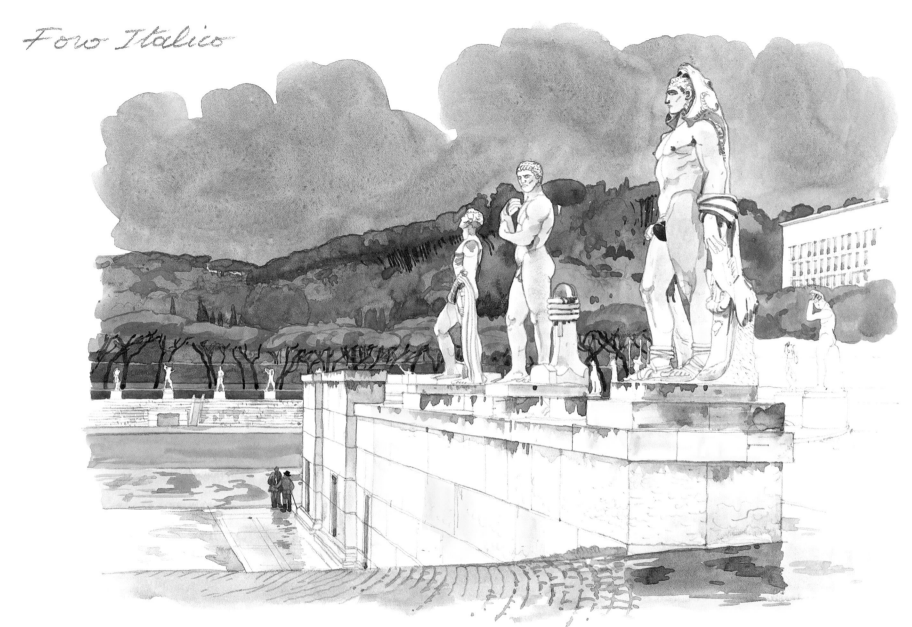

The Via Flaminia leads to
the Ponte Milvio, where Constantine
defeated Maxentius. A few little
pockets of antiquity survive in this
modernised district, like this
"Little London" with English-
style houses.

On the other bank of the river is the Stadio dei Marmi,
built by the Fascists for the physical education of young
Italians, and opened in 1932 for the tenth anniversary
of Mussolini's rise to power. Each province sent a
statue in Carrara marble as a gift. There are sixty
colossal athletes, naked even when they represent
skiers or footballers. The group, however incongruous,
has a certain charm against its
background of wooden hills.

The Via Sallustiana is in the district where
the ancient historian Sallust, who unscrupulously
amassed fantastic riches as a governor
in Africa, created sumptuous and
famous gardens, called the
Orti Sallustiani.

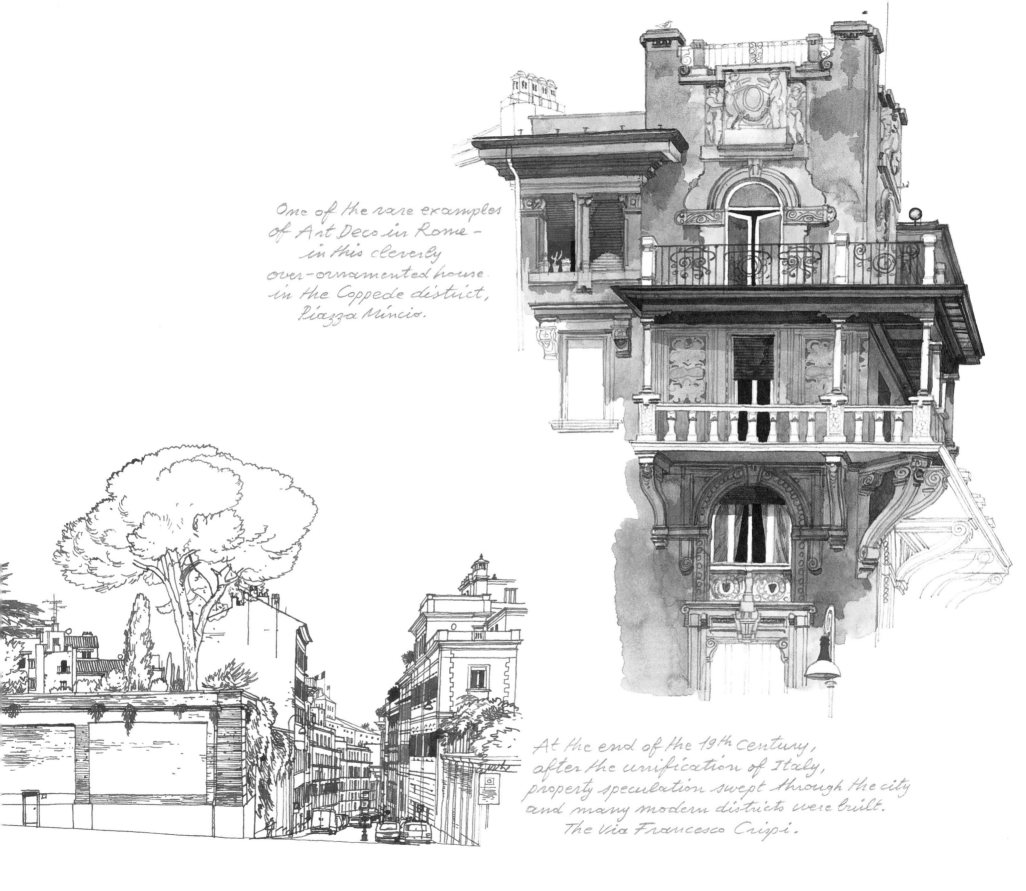

One of the rare examples
of Art Deco in Rome -
in this cleverly
over-ornamented house.
in the Coppede district,
Piazza Mincio.

At the end of the 19th century,
after the unification of Italy,
property speculation swept through the city
and many modern districts were built.
The Via Francesco Crispi.

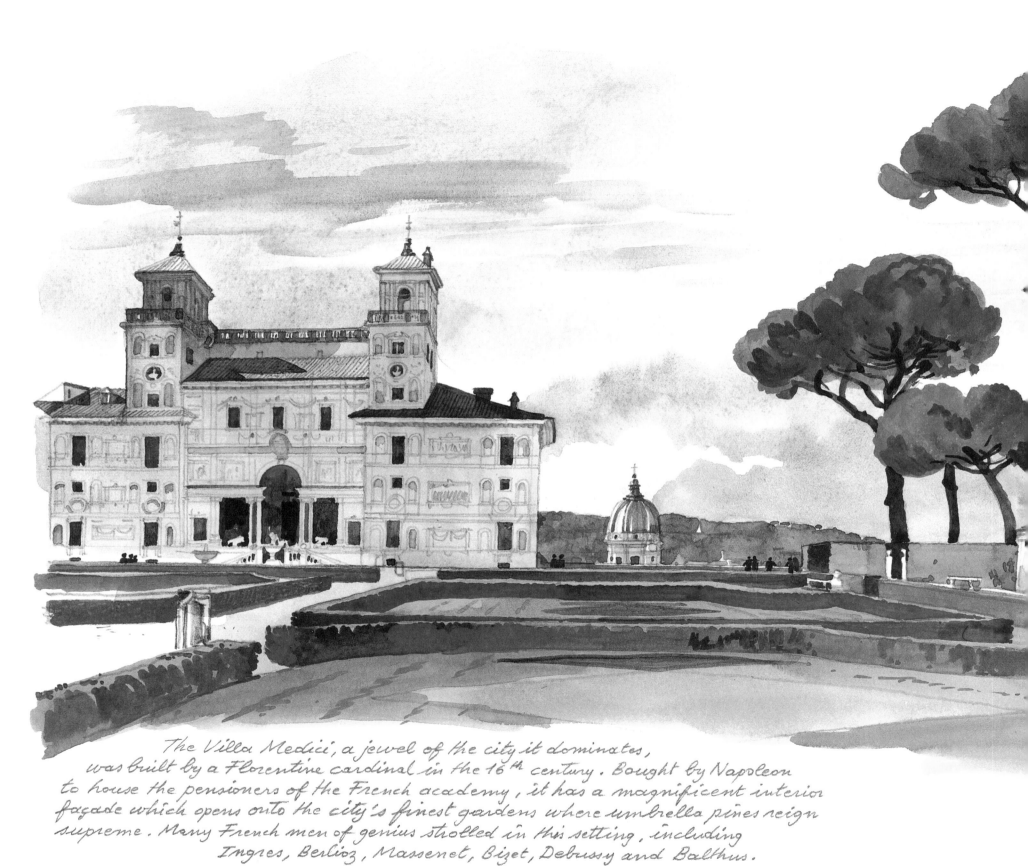

The Villa Medici, a jewel of the city it dominates, was built by a Florentine cardinal in the 16th century. Bought by Napoleon to house the pensioners of the French academy, it has a magnificent interior façade which opens onto the city's finest gardens where umbrella pines reign supreme. Many French men of genius strolled in this setting, including Ingres, Berlioz, Massenet, Bizet, Debussy and Balthus.

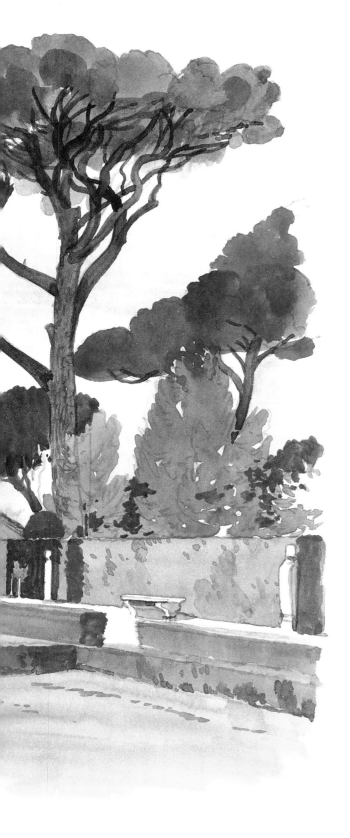

Villa Medici

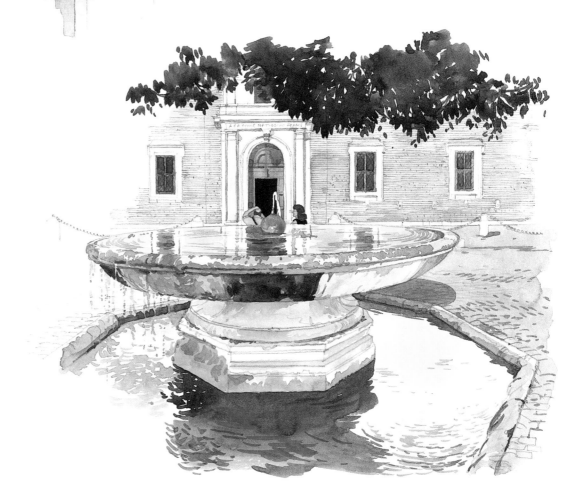

Chateaubriand, when he was
the French Ambassador, held fetes
in the Villa Medici.
In front of the external façade
stands the granite basin that
was immortalised by Corot.

377₄

Piazza di Spagna

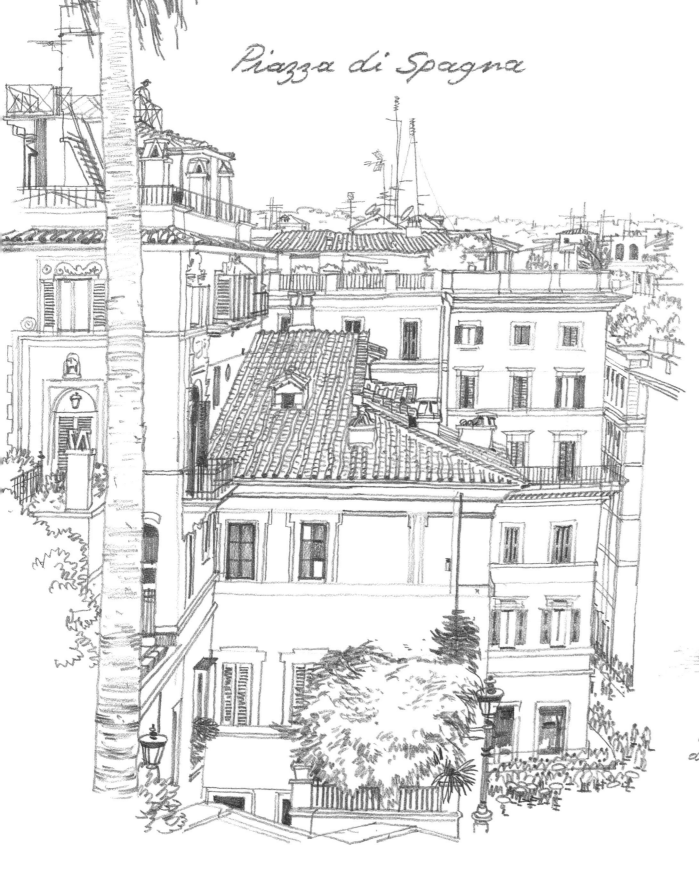

By the Spanish Steps, which lead from the Piazza di Spagna to the Villa Medici, stands the house where John Keats, the English poet, died.

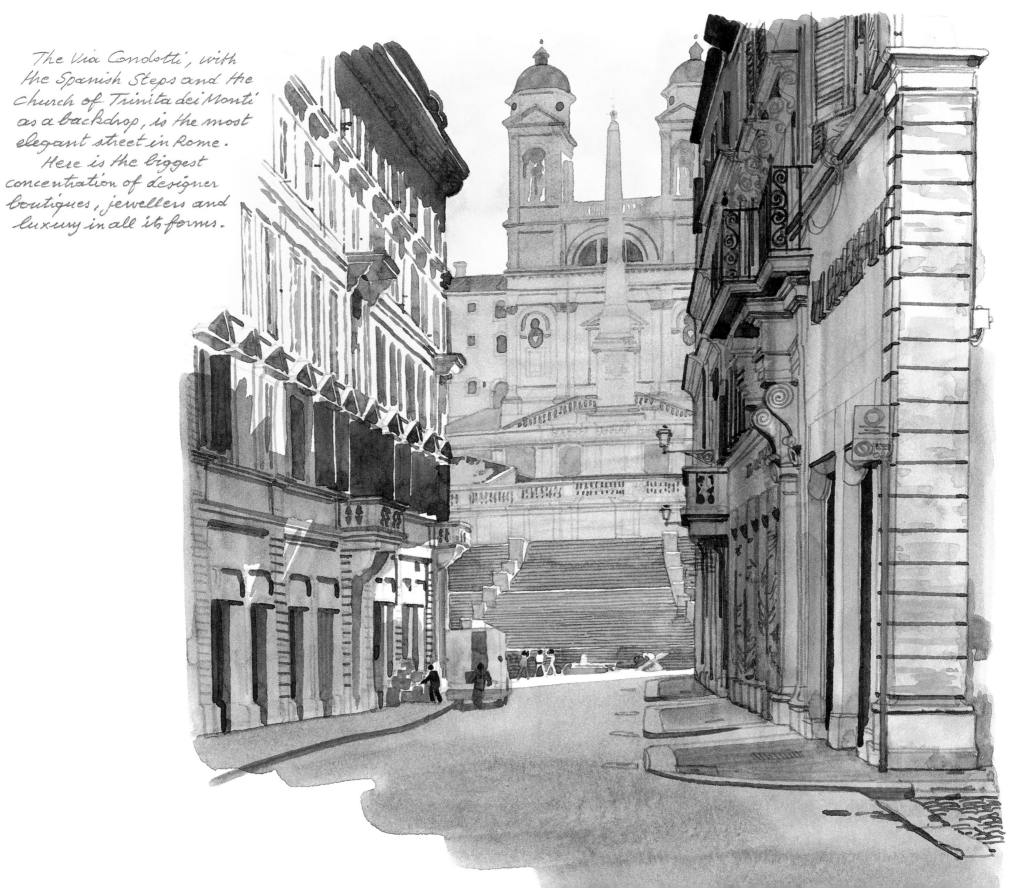

The Via Condotti', with the Spanish Steps and the Church of Trinita dei Monti' as a backdrop, is the most elegant street in Rome.
Here is the biggest concentration of designer boutiques, jewellers and luxury in all its forms.

Quirinal

On the Piazza Quirinale, in front of the Presidential
Palace, stand the statues of the Dioscuri, 5.60 metres high,
found in the Baths of Constantine and brought here
on the orders of Sixtus V. The obelisk was
added in the 18th century and the granite basin
in 1818 by Pius VII.

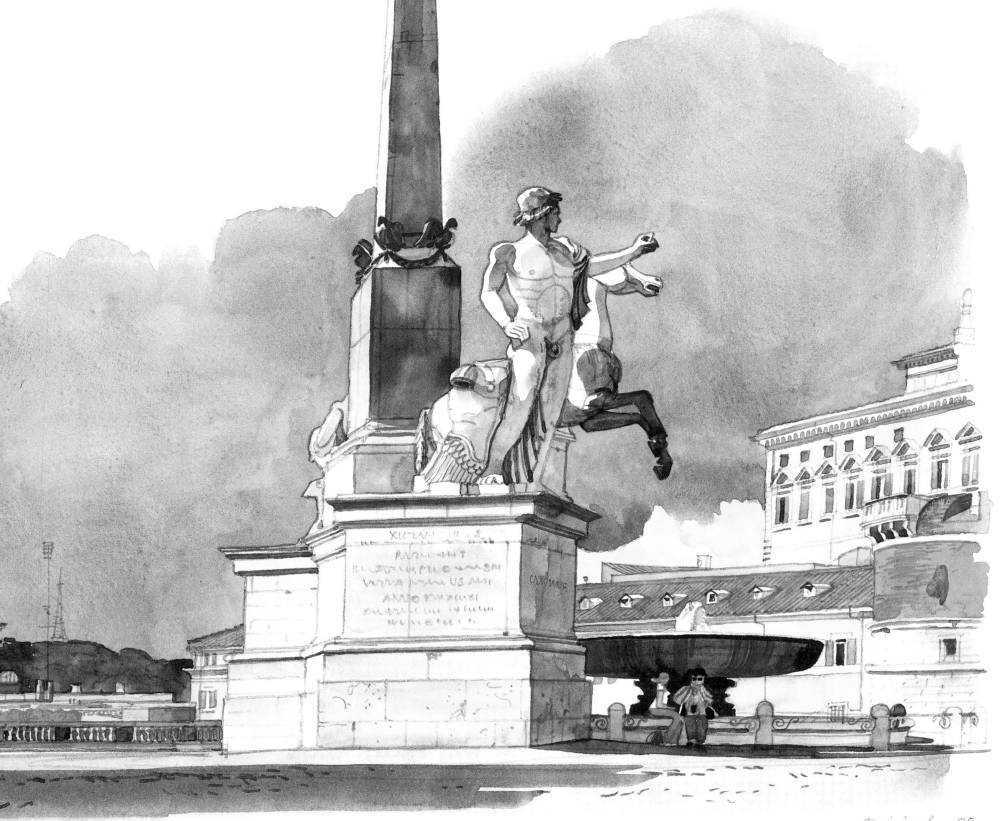

Quirinal 85

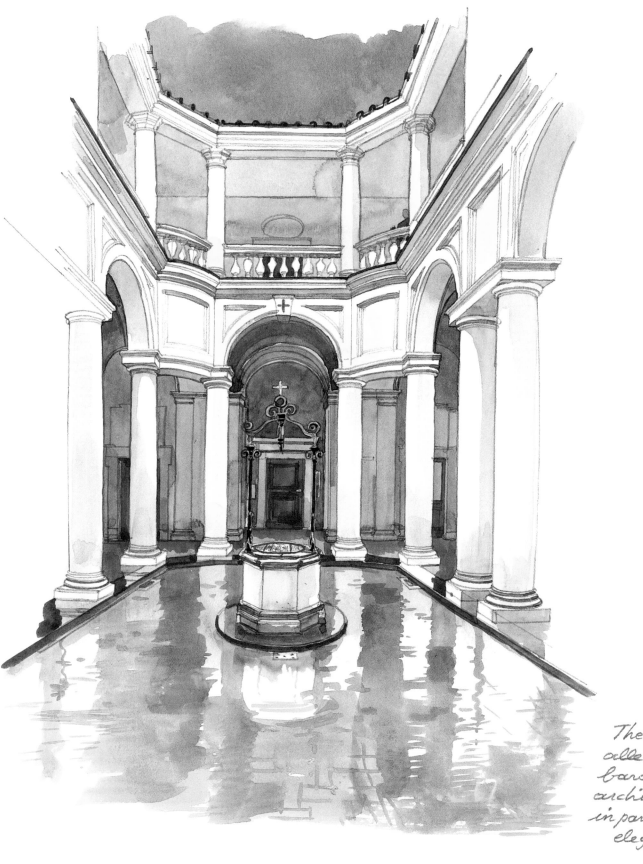

The Triton Fountain, in the Piazza Barberini, is one of the most ingenious of Bernini's baroque inventions. The four supporting dolphins glorify the triton, who is blowing a shell.

The Church of San Carlo alle Quattro Fontane is a baroque jewel created by the architect Borromini. The cloister in particular is a masterpiece of elegance and harmony.

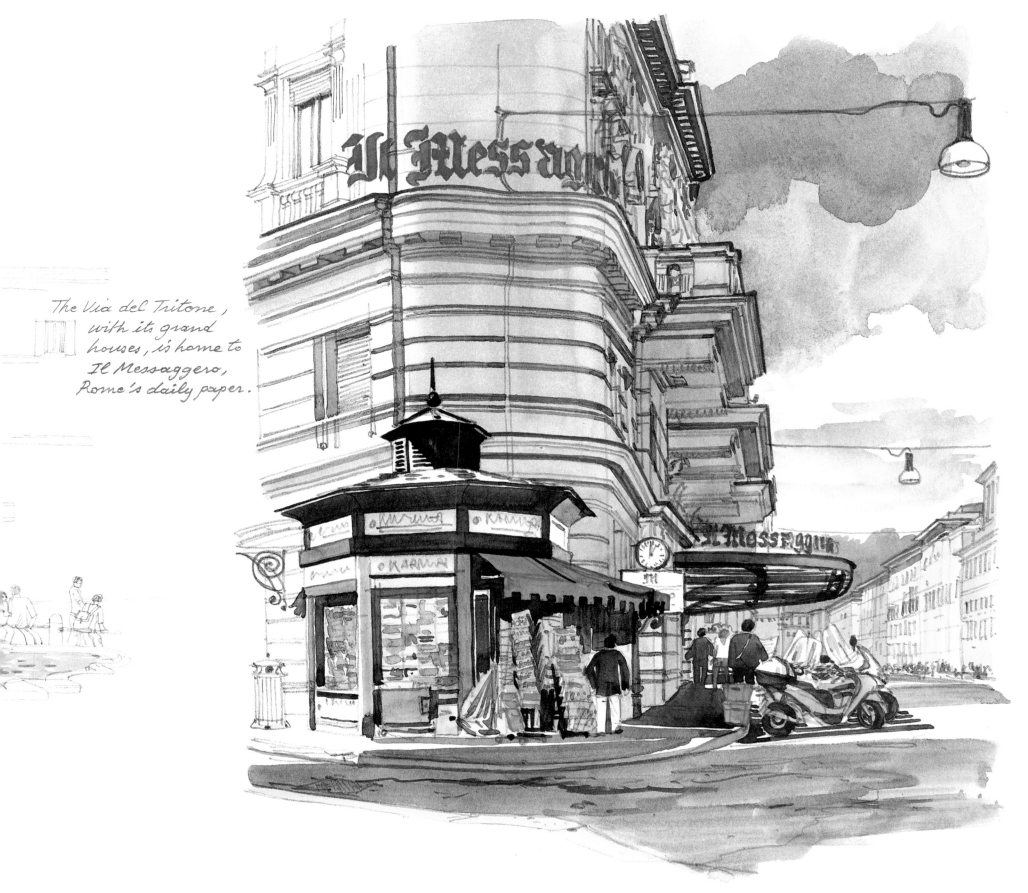

The Via del Tritone, with its grand houses, is home to Il Messaggero, Rome's daily paper.

Termini, Esquiline

The central railway station is built in a
determinedly modern style – white, bare, simple
and austere but its many arcades are a
throwback to classical architecture,
always close to the Roman heart.
The Termini district is one of the most
colourful and lively in the city.

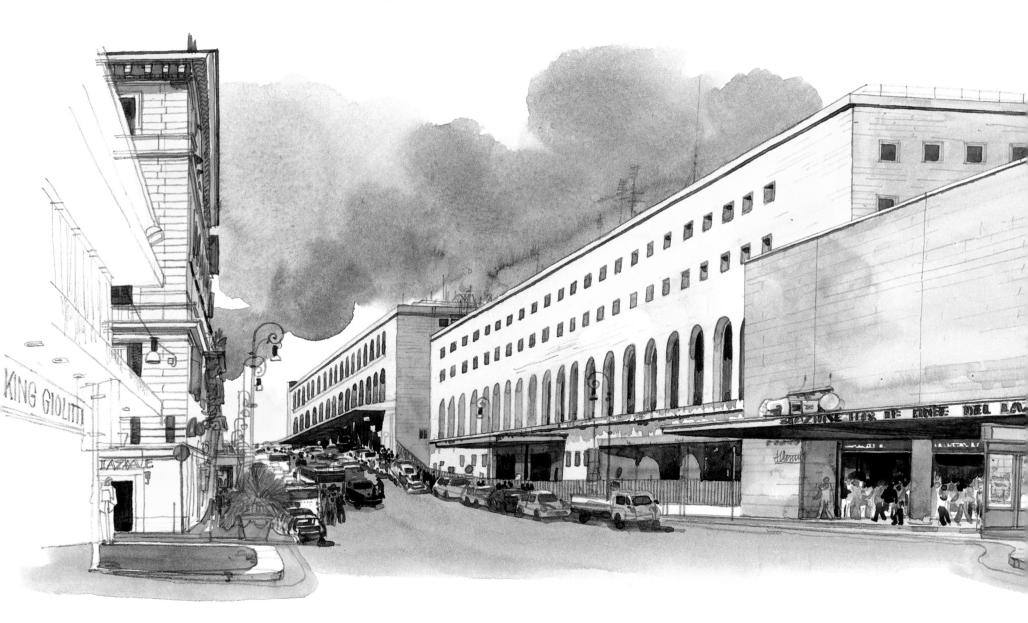

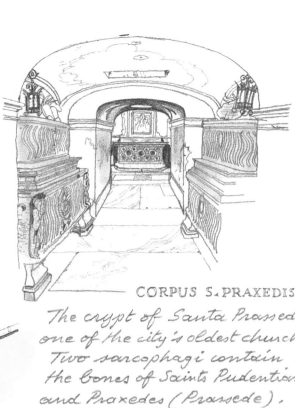

CORPUS S. PRAXEDIS.

The crypt of Santa Prassede,
one of the city's oldest churches.
Two sarcophagi contain
the bones of Saints Pudentiana
and Praxedes (Prassede).
the daughters of a man
said to have given shelter
to St Peter.

Santa Maria Maggiore is
so called because it is the
biggest of the many churches
in the city dedicated to the Virgin.
In the Middle Ages books deemed
heretical were burnt on the square.
The church was modified and enlarged
over the centuries. Seen from the Via Paolina.

Termini, Esquiline 83

On the Esquiline, one of the seven hills of Rome,
lived Maecenas, Virgil and Horace.
At the end of the 19th century a modern district was built here.
Piazza di Porta Maggiore where the crowds hurry to the tram stops.
Stuck in traffic jams, the people ignore the ancient walls.

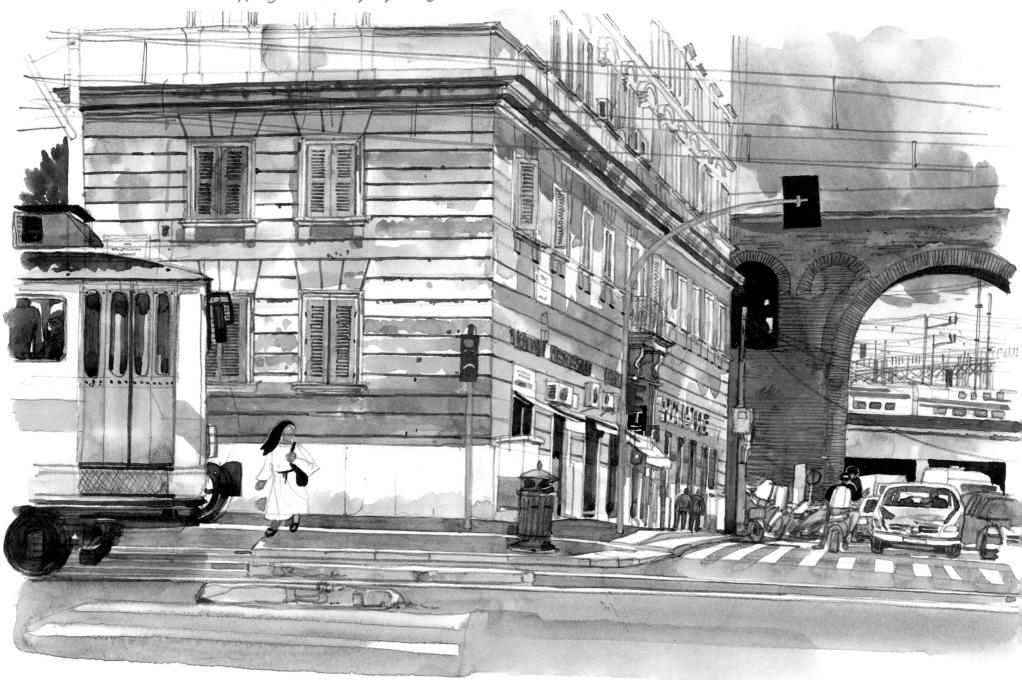

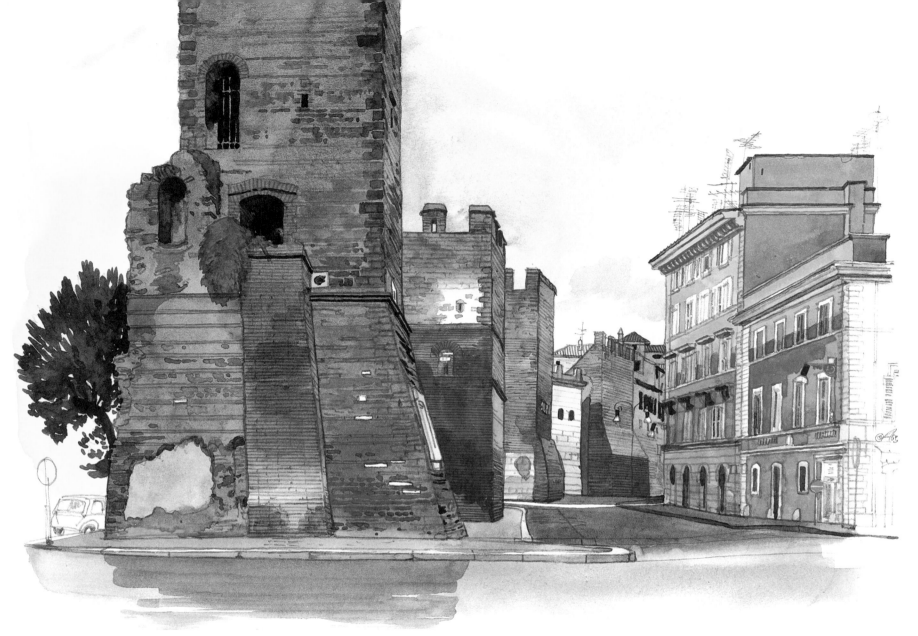

The Porta Tiburtina, one of the rare
gates that survive from the ancient
ramparts, opened on to the consular road
that led to Tivoli (ancient Tibur).
It offers proof that over the years the ground
level has risen so much that the road
nowadays almost touches
the top of the arch.

Lateran, Monti

Behind Piazza San Giovanni in Laterano,
vestiges of the Emperor Claudius's aqueduct are visible.
The square houses the palace and the Basilica of St John
Lateran, the cathedral of Rome and the centre
of the Christian world. Founded by Constantine
the Great, it was dedicated to the two Johns,
the Baptist and the Evangelist. Badly damaged
over the centuries, it was rebuilt
in the mid-17th century.

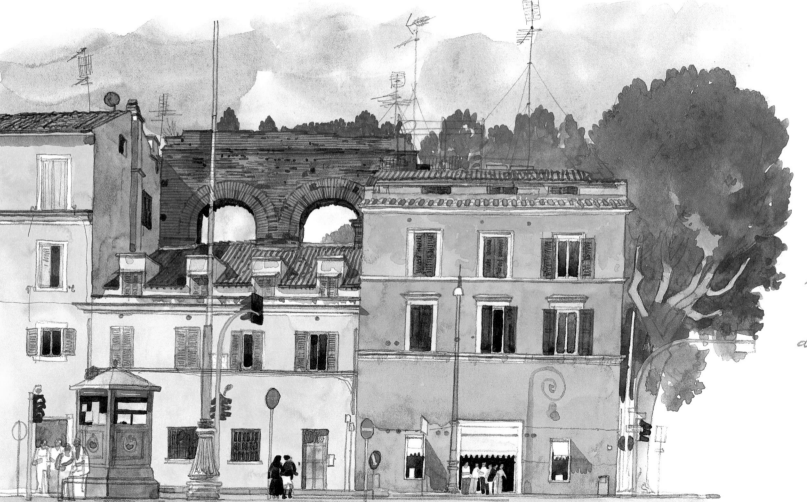

The front wall of
the façade of
the Basilica of
St John Lateran is
decorated with fifteen
statues, each seven
metres high. They show
Christ, the two Johns
and the principal
doctors of the Church.

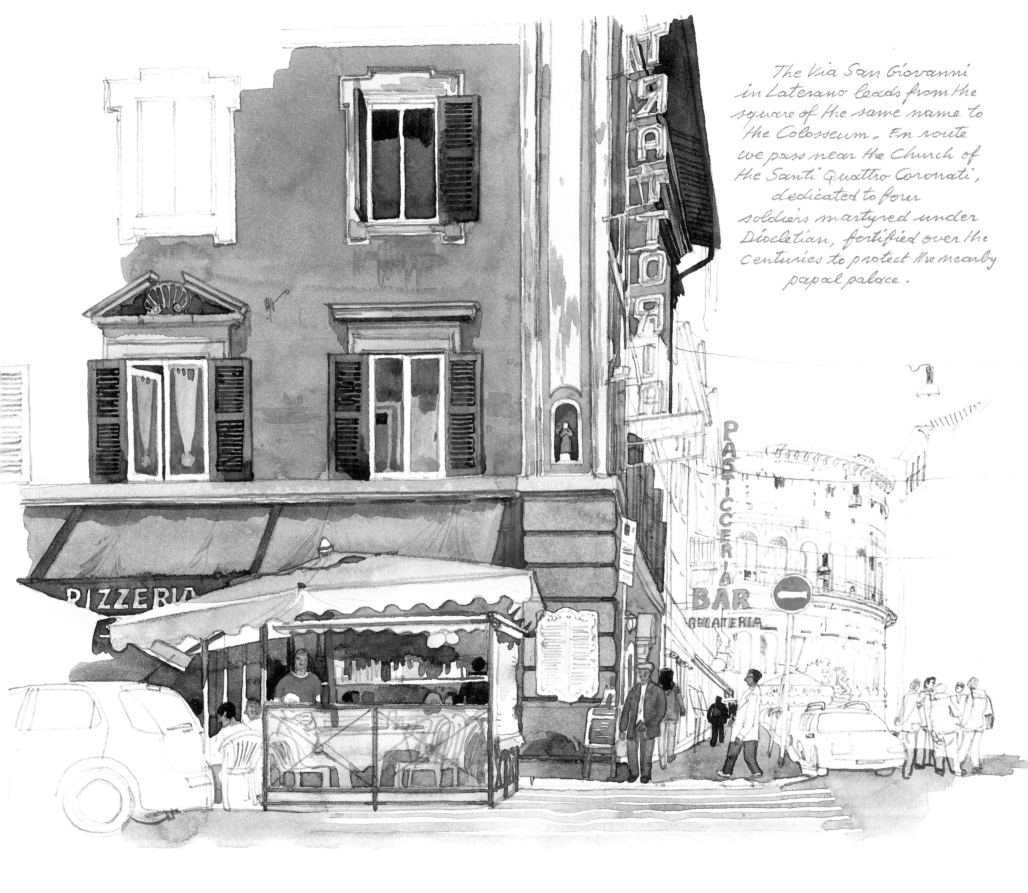

The Via San Giovanni
in Laterano leads from the
square of the same name to
the Colosseum. En route
we pass near the Church of
the Santi Quattro Coronati,
dedicated to four
soldiers martyred under
Diocletian, fortified over the
centuries to protect the nearby
papal palace.

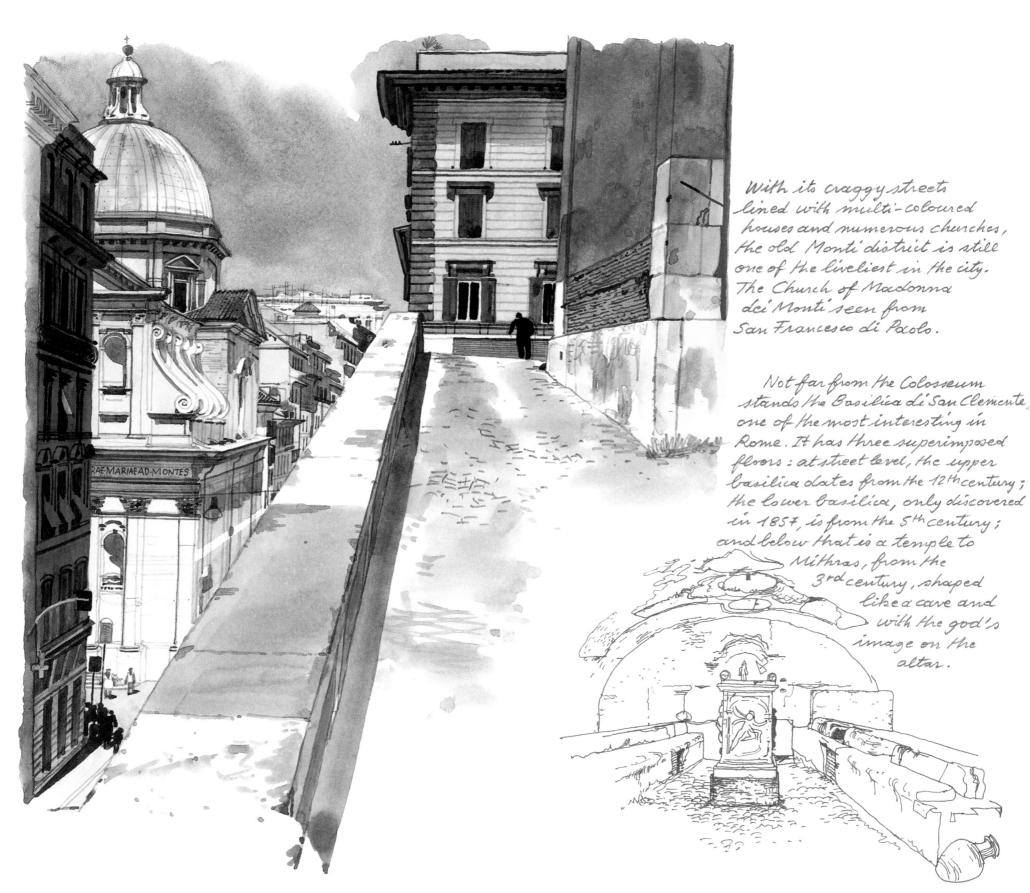

With its craggy streets lined with multi-coloured houses and numerous churches, the old Monti district is still one of the liveliest in the city. The Church of Madonna dei Monti seen from San Francesco di Paolo.

Not far from the Colosseum stands the Basilica di San Clemente one of the most interesting in Rome. It has three superimposed floors: at street level, the upper basilica dates from the 12th century; the lower basilica, only discovered in 1857, is from the 5th century; and below that is a temple to Mithras, from the 3rd century, shaped like a cave and with the god's image on the altar.

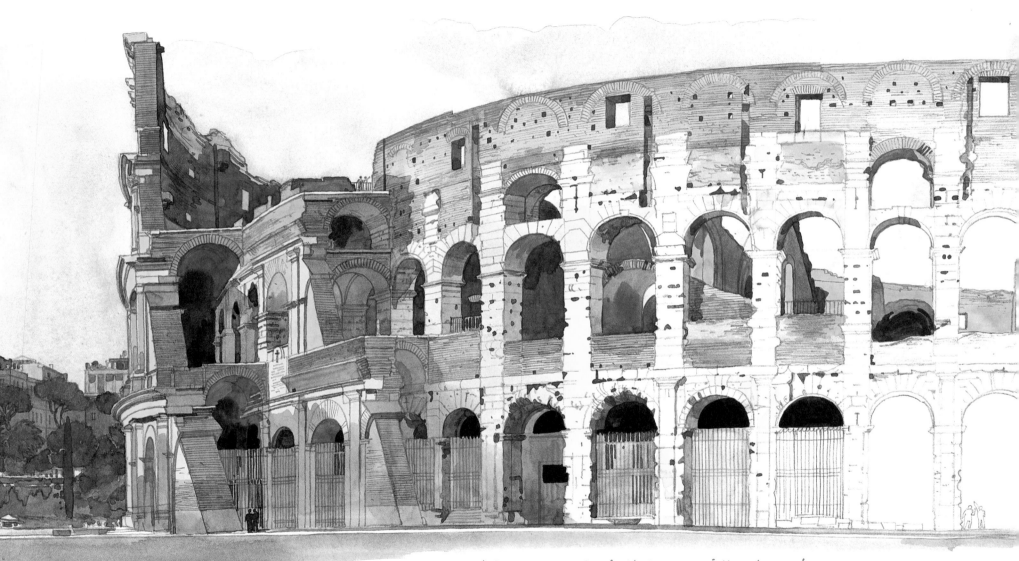

You cannot visit Rome without seeing
the Colosseum, a "colossal" amphitheatre where
fierce fights between gladiators and wild animals were
held. Contrary to myth, the first Christians were not put
to death here. The missing stones were taken to build palaces
and churches, in particular the Palazzo Venezia and
St Peter's in the Vatican.

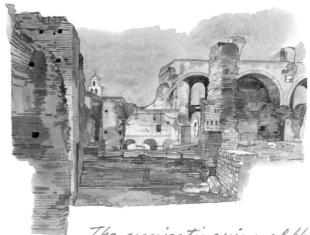

The majestic ruins of the Basilica
of Maxentius stand in the
middle of the Forum.